IMAGES
of America

PERINTON, FAIRPORT,
AND THE ERIE CANAL

This book is dedicated to all the members and friends of the Perinton Historical Society whose generous donations of local artifacts, photographs, and documents over the years have made this book possible.

IMAGES
of America

PERINTON, FAIRPORT, AND THE ERIE CANAL

Perinton Historical Society

Betty Bantle
Sharon Catanese
Alberta Cleveland
Cindy Coupal
Lorain Francis
Linda Herne
William Keeler
Joyce Lyle
Lucy McCormick
Ruth Post

ARCADIA
PUBLISHING

Copyright © 2001 by Perinton Historical Society
ISBN 978-0-7385-0532-9

Published by Arcadia Publishing
Charleston, South Carolina

Printed in the United States of America

Library of Congress Catalog Card Number: 00-111689

For all general information contact Arcadia Publishing at:
Telephone 843-853-2070
Fax 843-853-0044
E-Mail sales@arcadiapublishing.com
For customer service and orders:
Toll-Free 1-888-313-2665

Visit us on the Internet at www.arcadiapublishing.com

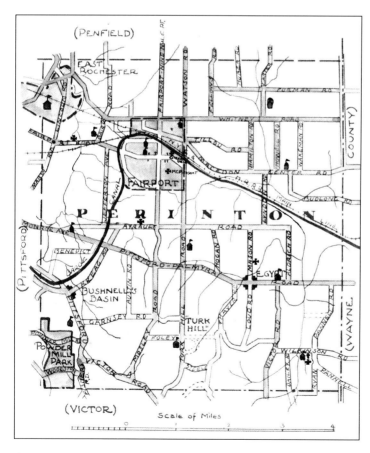

Shown is a map of Perinton.

Contents

Acknowledgments		6
Introduction		7
1.	The Erie Canal	9
2.	Egypt, Perinton	19
3.	Bushnell's Basin and Rand's Powder Mill	29
4.	Despatch, East Rochester	35
5.	Downtown Fairport	43
6.	DeLand's Chemical Works	59
7.	Cobb's Preserving, Sanitary and American Can	67
8.	Vinegar to Certo	77
9.	Crystal Springs Water	83
10.	Community Activities	89
11.	Churches, Schools, and Organizations	103
12.	Old Home Week	119

ACKNOWLEDGMENTS

Special thanks go to the following: Donovan Shilling, author of *Rochester's Lakeside Resorts & Amusement Parks*; the Perinton Historical Society Board of Trustees and Executive Committee; Matson Ewell, director of the Fairport Historical Museum; Imogene Blum, curator of the Fairport Historical Museum; Bill Matthews, president of the Perinton Historical Society; Jean Keplinger, Perinton town historian; Sue Roberts, historian; Mary Connors and James Burlingame, East Rochester historians; and James Keeler, computer consultant.

INTRODUCTION

The story of Perinton and the birth of Fairport is intrinsically tied to the completion of the Erie Canal. This waterway—sometimes called "Clinton's Ditch" after the New York governor who supported the project—was an engineering marvel of the early 19th century. As the longest canal in the world, it stretched from Buffalo and Lake Erie to Albany and the Hudson River. The hamlets and cities that the canal passed through took advantage of this man-made river to ship goods and wares to distant ports. Soon, these stops became magnets for settlers traveling west in search of opportunities and rich farmlands. Nearby Rochester was one of these western boomtowns. The village grew from a population of 331 to a city of 11,000 in just eight years.

Before the Erie Canal was built, the area known today as Perinton was a sparsely settled wilderness. Carved out of the Phelps and Gorham land purchase in 1790, the township of Northfield was first surveyed by Glover Perrin and Caleb Walker. Perrin, whose name was taken for the town in 1812, settled with his family on a small farm on what is now Ayrault Road.

In 1806, the first settlement was established in Egypt. Egypt was founded along the east-west stagecoach route from Rochester to Canandaigua. Its location and fertile land made it a natural gathering point for settlement, and with the formation of the town of Perinton in 1812, the first town meeting was held there in 1813. The fortunes of the village began to decline in 1825, when the Erie Canal was completed, and transportation patterns and settlement shifted to the north and west along the canal.

Bushnell's Basin rose in importance as the western end of the Erie Canal in 1821, before the building of an embankment across the Irondequoit Creek Valley. Boats in Rochester with eastbound cargo would have to unload goods at Pittsford and then travel by road to Bushnell's Basin. From there, they would reload shipments onto packet boats for the trip east, as far as Little Falls. Warehouses and taverns were established in the basin, and the settlement continued to be an important port in the 19th century.

The rise of Fairport as the dominant settlement along the canal was due in part to the Fairport-Perinton Road, which provided a route for farmers in the north to transport their goods to the canal. Warehouses, stables, stores, and inns sprang up. In 1852, the DeLand Chemical Works built a large factory along a straight stretch of the canal in the village. This was the beginning of Fairport's industrial heritage, which continued into the 20th century.

In western New York, the population increase due to the canal brought competition from the railroads. Starting c. 1850, two railroads—the New York Central and the West Shore

Railroad—began passenger and freight traffic through town. Both rail lines, the canal, and the Fairport-Penfield Road all converge in a one-block section of Fairport, making the village the ideal spot for business and industry. Companies such as Cox Shoe Manufacturing, the G.C. Taylor Patent Medicine Depot, the Douglas Packing Company, and the Sanitary Can Company all built factories near the canal and rail lines.

The railroads gave rise to the village of Despatch in the northwest section of Perinton. In 1897, Walter Parce persuaded the Merchants Despatch Company to relocate its railroad car manufacturing operation to the northwest section of town. This factory was directly responsible for the building of a planned residential community, eventually known as East Rochester.

The town of Perinton and the village of Fairport changed after World War II. The factories and businesses in the first part of the century were going out of business or were being sold and moved to other locations by larger companies. The last large factory to close was the American Can Company in 1993. The Barge Canal, an enlarged version of the Erie Canal, continued to play a vital role in the transportation of goods across New York, but the emergence of the trucking industry with door-to-door service made it unnecessary for an industry to be located on a canal or rail line. By the end of the 1950s, the canal had become obsolete. Suburban housing transformed the rolling hills and farms into large subdivisions, increasing the population of Perinton to more than 43,000 people by 1998.

Today the town of Perinton and the village of Fairport are changing again. The Erie Canal, the source of industrial growth in the mid-19th century, is being used to spur new initiatives for tourists. The reuse of older buildings, the modernization of docking facilities, and the paving of the old Erie Canal towpath through Fairport has made this section "the Jewel of the Canal." By combining new paths with old transportation routes (such as the Rochester, Syracuse, and Eastern trolley bed and the Erie Canal towpath), the Crescent Trail Association and the town have developed a great number of trails. Perinton is now known as "Trail Town, U.S.A."

This book is a testament to the resourceful and energetic people of this community. In these pages, readers will get a sense of Perinton and Fairport's past and get a glimpse of the community's future.

—William Keeler
October 2000

One
THE ERIE CANAL

Low bridge, everybody down, low bridge 'cause we're coming to a town.
—Thomas S. Allen, "Fifteen Years on the Erie Canal"

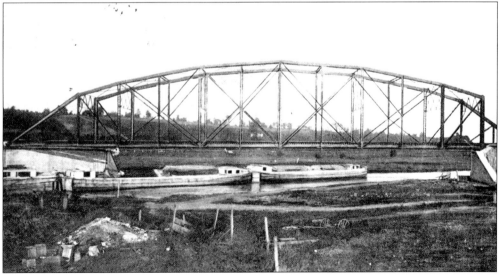

The Erie Canal winds its way for 8 miles through the town of Perinton. In the early 1800s, the canal provided irrigation for farms and ports for passengers and produce. It was also an important transportation link for industries that sprang up in the village of Fairport. Above is the Rochester, Syracuse, and Eastern trolley bridge, one of many bridges that span the canal in Perinton.

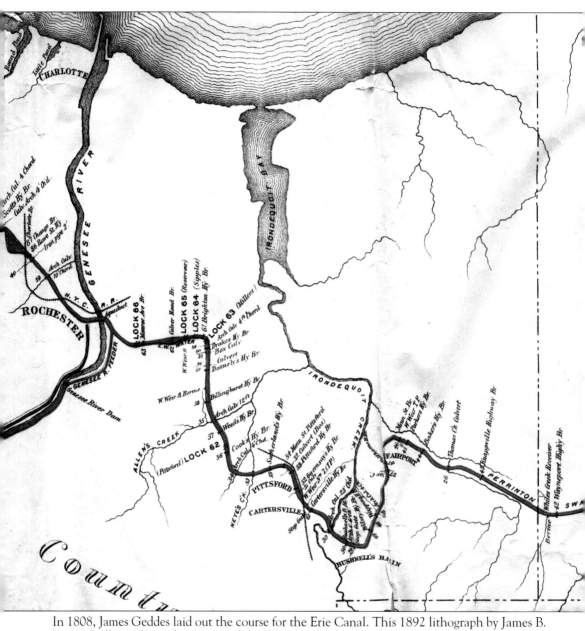

In 1808, James Geddes laid out the course for the Erie Canal. This 1892 lithograph by James B. Lyon of Albany shows the section of the Erie Canal extending from Rochester to the Perrinton Swamp. The canal was routed southeast across the Irondequoit Creek Valley and proceeded north and then east to take advantage of the low-lying swamps. This route avoided the hilly southern region but bypassed many of the older, more established communities such as Geneva and Canandaigua.

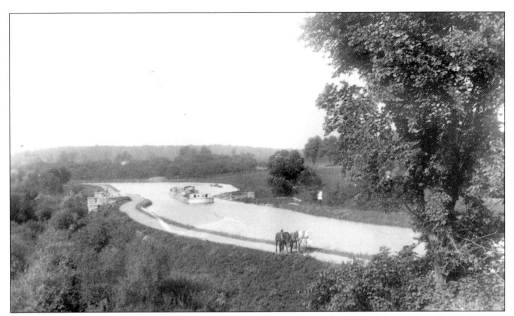

Construction of the canal began in 1820 and was completed from Buffalo to New York City on October 26, 1825. The cost of transporting goods was reduced by 80 percent, and the time to transport those goods changed from six weeks to ten days. Horses or mules pulled barges and packet boats into the early 20th century.

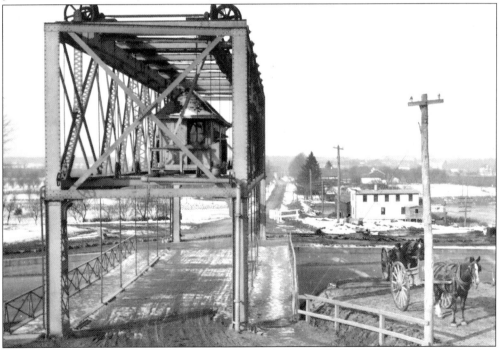

Settlements grew around the bridges that spanned the canal. Fullam's Basin was a favorite disembarking point for passengers traveling west. They would take a stage to Rochester because it was faster than taking the packet boat all the way into the city. This early-20-century picture shows the metal lift bridge that replaced the wooden one.

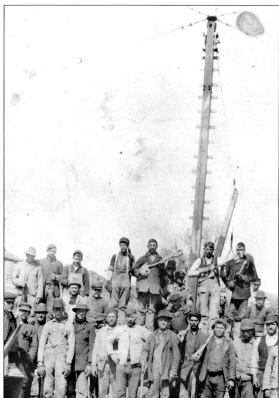

The original Erie Canal was 40 feet wide and 3.5 to 4 feet deep. Because the canal was such a success, it was deepened to 7 feet in 1862 to accommodate heavier boats. Repairs and improvements to the canal were a constant source of work for local and immigrant labor. This picture shows a local work crew in 1895.

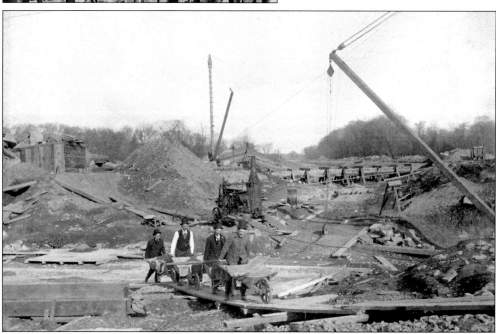

Most of the laborers on the canal were unskilled European immigrants, especially from Ireland. Shovels, wheelbarrows, and mules were used to accomplish the digging. The wooden cranes shown here were used to haul large rocks out of the ditch.

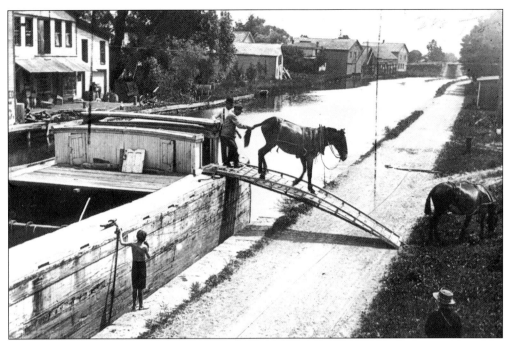

Mules were changed every 8 to 10 miles. Canal horns were used to alert boarding stables of the arrival of a canal boat. The number of blasts on the horn would indicate how many fresh mules were needed. In this picture, courtesy of the Perinton town historian, a man holds a mule's tail to keep it on the ramp.

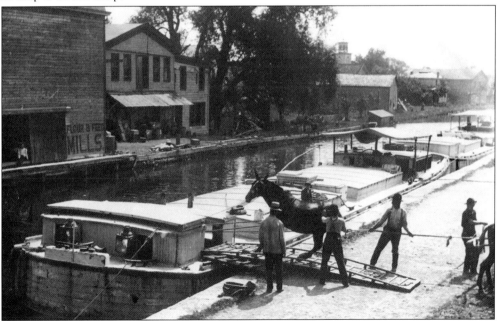

Sleeping quarters for passengers on a packet boat were in the front, and the spare mules were kept in the back. Passengers were charged 1½¢ per mile and 50¢ per day for meals. Here, a mule is being coaxed back onto the boat with the aid of a pulley. This picture is courtesy of the Perinton town historian.

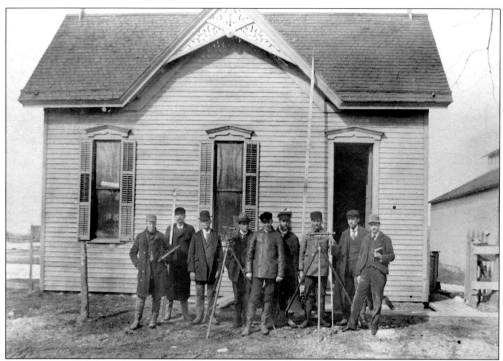

The Erie Canal was enlarged again, beginning in 1904. Some parts were deepened to a depth of 12 feet, and new sections were dug to improve the flow and reduce the severity of turns on the canal. This picture shows the engineering corps led by C.M. Smith (far right), who began surveying in 1910.

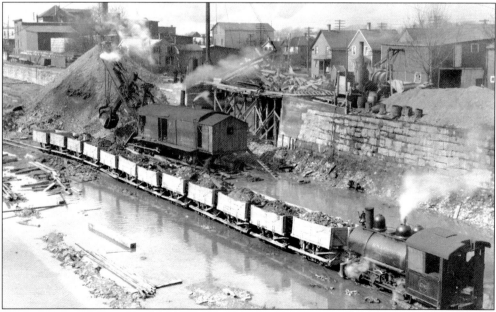

By 1912, the age of steam had arrived, and most of the work was done by steam-powered shovels and trains. This picture shows the construction of the new waste weir between Main and Parker Streets in Fairport.

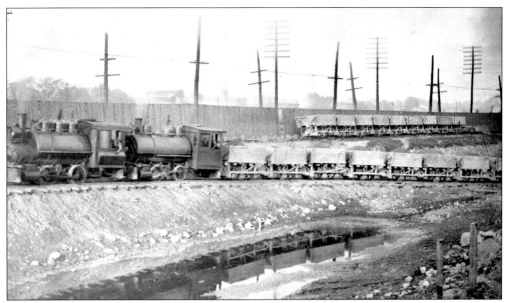

Shown in this view looking north, just west of the Main Street Bridge in Fairport, is a train that was used to take dirt out of the canal. The fence in the background was constructed c. 1906 by the Rochester, Syracuse, and Eastern Railroad to keep the trolleys from frightening the mules along the towpath.

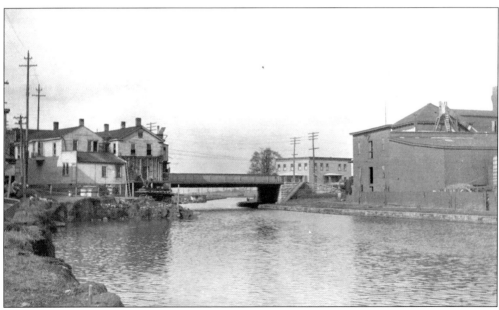

The canal remained open throughout the reconstruction. This photograph from the summer of 1912 shows the canal in the village of Fairport. The canal had been widened as far as the buildings on the left, which were taken down the following winter.

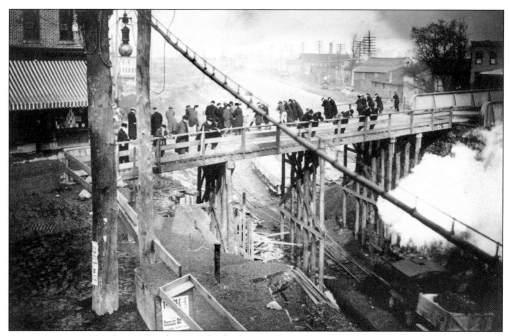

A temporary Main Street Bridge was built during the reconstruction. The men on the bridge are sidewalk superintendents checking the structure. The scaffolding shows the amount of extra width taken for the expansion, which increased from 70 to 123 feet.

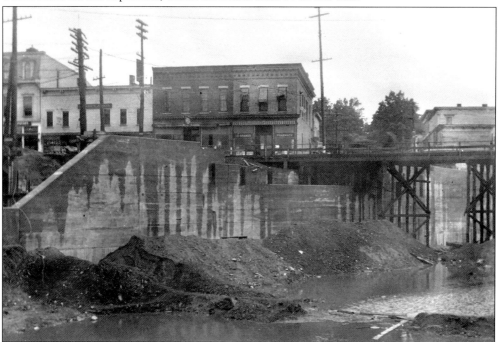

This photograph shows the south abutment for the new Main Street Bridge. The widening of the canal placed many buildings within several feet of the banks. The building to the far right was so close to the canal that a local woman would sometimes climb to the top of the building and dive into the water.

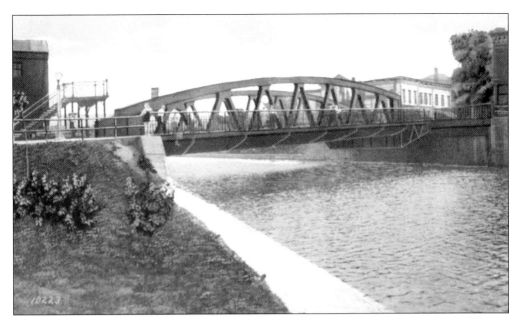

The Main Street Bridge in Fairport has appeared several times in *Ripley's Believe It or Not*. The bridge is an irregular, ten-sided structure and crosses the canal at a 32-degree angle. No two angles in the bridge are the same and no corners on the bridge floor are square.

Because of the sandy soil of the canal, breaks occur from time to time. One of the early breaks was at the Oxbow on April 28, 1871. It was determined that the break was made by a burrowing muskrat. A canal boat named the *Bonniebird* was carried inland for three-quarters of a mile before being set in a tree, 19 feet off the ground.

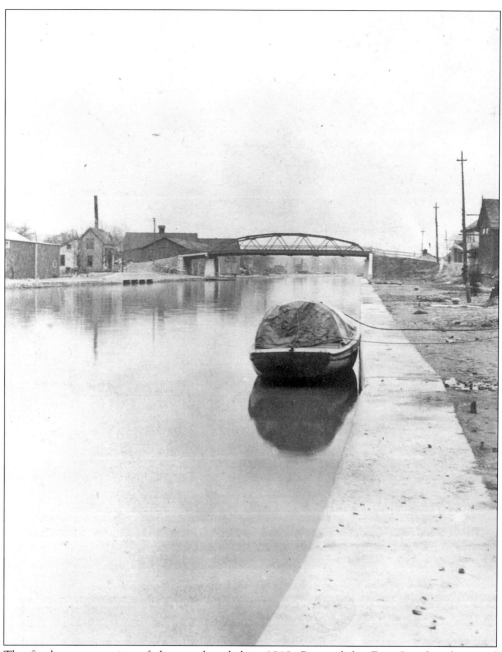

The final reconstruction of the canal ended in 1918. Parts of the Erie Canal and natural waterways were used to create the New York Barge Canal system. The new canal was mechanized, and all mules and horses were barred from the towpath. The reconstruction shortened the canal from 350.5 to 340.7 miles. Clearance under bridges was increased from 11 to 15.5 feet, and the capacity of barges on the canal increased from 250 to 2,000 tons. After World War II, the New York Barge Canal became obsolete as the highway system and the trucking industry developed. Recreational use of the canal increased at that time and continues today. The 70 miles of canal along the old Erie Canal towpath, between Lockport and Fairport, is now called the Erie Canal Heritage Trail.

Two

Egypt, Perinton

When Jacob learned that there was grain in Egypt, he said to his sons . . . I have heard that there is grain in Egypt. Go down there and buy some for us, so that we may live and not die.

—Genesis 42:2

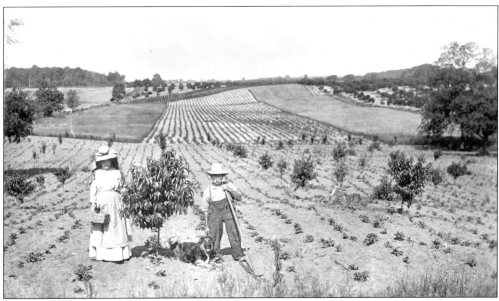

Egypt was the first settlement in the newly formed town of Perinton in 1812. The first Perinton town meeting was held in Egypt's Packards Tavern on April 6, 1813. Fairview Farm, shown in 1912, typified Perinton and Egypt's agricultural roots. In the early 1800s, successful farmers, such as the Ramsdells, raised large quantities of corn, which settlers would travel long distances to purchase. Egypt was named by farmers in reference to the above quotation from the Bible.

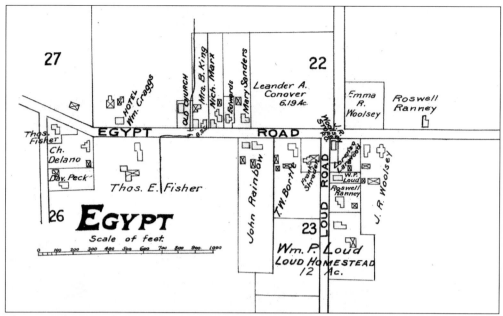

This map of Egypt is from the 1902 *Plat Book of Monroe County*, by J.M. Lathrop & Company. In 1806, a stage and mail route was cut through the woods connecting Rochesterville with Palmyra. Egypt began as a stop to change and shoe horses for the stagecoaches. It had a stage depot, two stores, a post office, a smithy, and a wagon shop. Egypt's fortunes began to fall shortly after the Erie Canal opened in 1825.

The Ramsdell House, sometimes referred to as "Ramsdell's Castle," was raised without the aid of whiskey in 1816. It was said that sober workers were safer on the job and happier by the end of the day. As Quakers and abolitionists, the Ramsdells opened their home to fleeing slaves as part of the Underground Railroad. The house still stands at 173 Mason Road.

Oliver Loud ran a tavern in 1812 that he called the "House of Entertainment." His father-in-law, J.P. Eleazer Bateman, held court sessions in the tavern to settle fights between workers from the canal construction. Oliver Loud also made astrological calculations for the *Western Almanack* from 1820 to 1830.

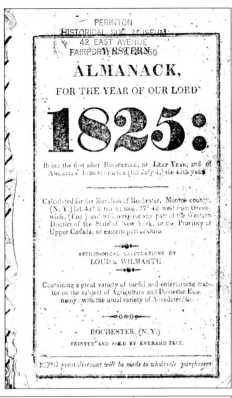

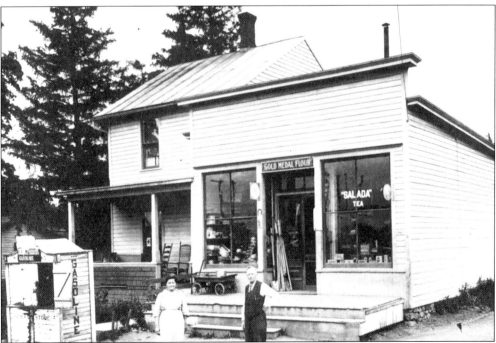

One of the few remaining storefronts in Egypt today is Nelson's Store, located on Route 31. This picture shows how the store looked in 1914. Posing are the proprietors, Mr. and Mrs. Willis Andrews.

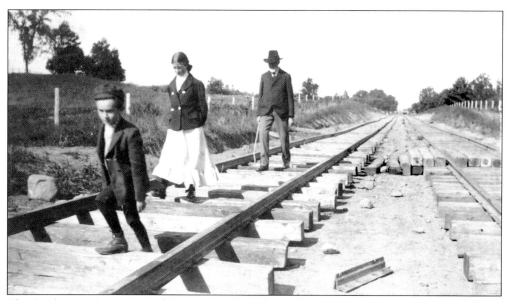

The Rochester, Syracuse, and Eastern Railroad began laying trolley tracks through Egypt in 1906. The trolley began service from Macedon to Egypt on August 8, 1906, and had its last run in 1931. This image shows a family walking along the newly set rails in Egypt.

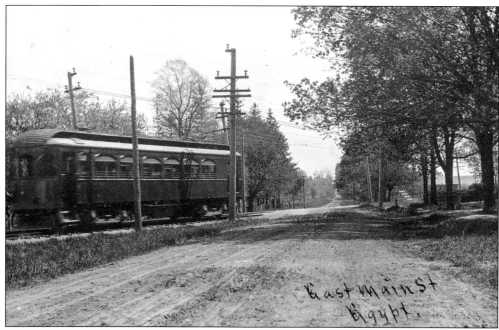

The "On Time Line," as the trolley was called, ran from Rochester to Syracuse on a double set of tracks, one set going east and another going west. In 1926, a one-way trip from Rochester to Egypt cost 48¢. Here, the trolley is crossing Main Street in Egypt, near stop No. 18.

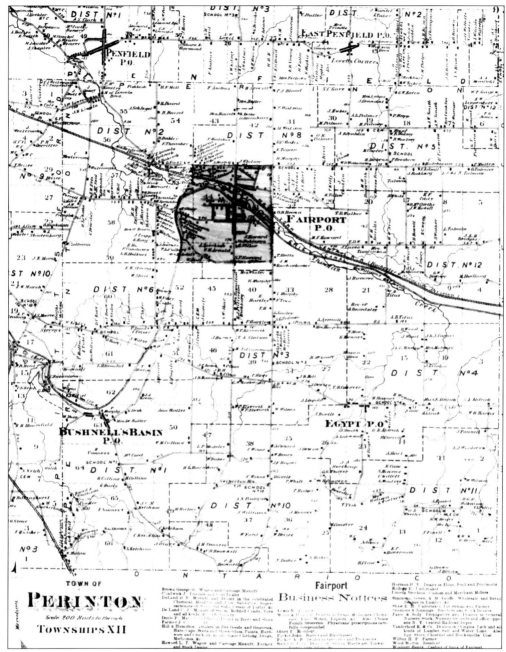

The area now called Perinton was first part of a larger town called Northfield, formed in 1808. The town was later named Boyle. In 1812, the current boundaries were established and the new town was named Perrintown after Glover Perrin, one of the first settlers to the area. Perrin, who first came to the region in 1790 to survey the new township, built a small cabin on what is now Ayrault Road.

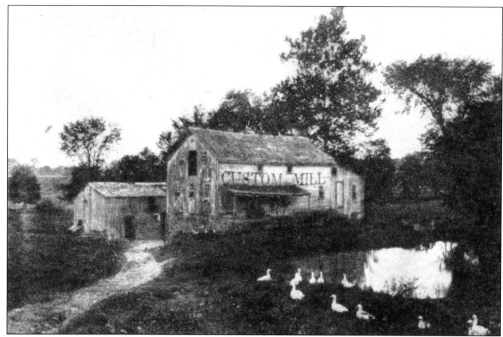

Early flour mills and lumbermills proliferated along the many creeks in Perinton. The Jefferson Mill, pictured here, was built in 1810 along Thomas Creek and was still in operation into the 1890s. The Free Will Baptist Church congregation from Fairport would ride down to the mill after Sunday school and perform baptisms in the creek next to the millpond.

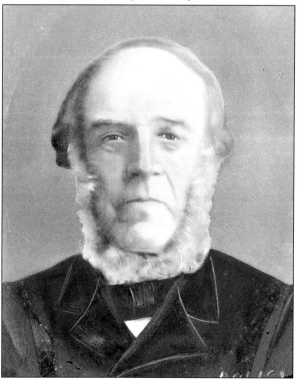

David Cady was an early settler in Perinton. He was an aide to Gen. George Washington in the American Revolution. Captain Cady's headstone reads, "Here sleeps the dead who once has fought on Brandywine but not for fame was wounded for his country sought the Blessing of liberty and we Revere his name."

This is the Ellsworth home, which was near the corner of Turk Hill and Ayrault Roads. The Ellsworths, a prominent family in Perinton, started the first manufacturing business in the town by making fence posts and caps for local farmers.

Clarence and Arthur Pike were brothers who made baskets for a living in the 1800s, just west of the village of Fairport. The street where they made their wares was named Basket Road. The road was later renamed Jefferson Avenue after a local miller.

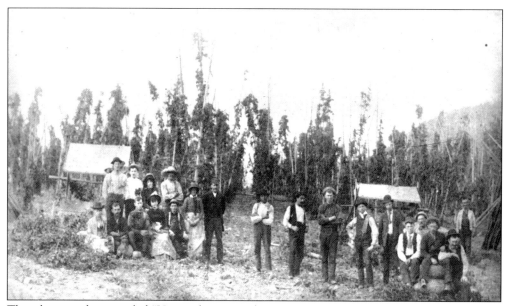

This photograph is entitled "Hop gathering in the 1880s." Poles would be staked in the ground and the hops were trained to grow up the poles. At the height of hop production, in 1865, Perinton produced 8,000 bushels of hops.

Jesse B. Hannan was Perinton's supervisor for two terms—from 1867 to 1868 and from 1881 to 1886. He was a teacher in the Valentown Hall School in nearby Victor and was successful in growing grain on his 200-acre farm on Pittsford Palmyra Road.

The Howard brothers came to Perinton in 1832. Ansel Alonzo Howard, the eldest pictured on the far right, settled on Turk Hill Road and ran a blacksmith business in the village of Fairport at 36 South Main Street.

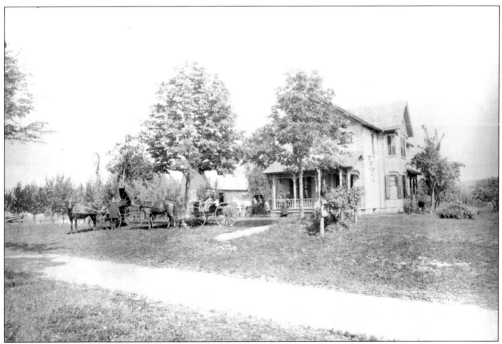

This photograph shows James McMillan's residence, located at 6004 Pittsford Palmyra Road. James McMillan and Ebenezer Cady worked together driving wells. In 1870, McMillan patented an improved tubing device, which he had on display in his basement for many years.

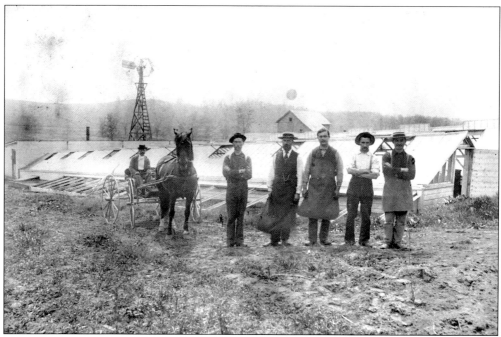

The Salter Brothers Nursery moved from Rochester to the corner of Moseley Road and Hulbert Avenue in 1885. The nursery grew carnations and violets, which were cut, stored in an icehouse, and shipped to Rochester by train. George Hart bought the business in 1918. The site is now occupied by a complex of townhouses called Westage at Harts Woods.

The Rochester, Syracuse, and Eastern trolley opened up farmlands along its route to suburban development. One of Perinton's first residential subdivisions was built by Carl Patterson on Baird Road, near stop No. 11. He built several houses on the street between 1906 and 1915. This photograph is courtesy of the Perinton town historian.

Three
BUSHNELL'S BASIN AND RAND'S POWDER MILL

The great embankment across the Irondequoit, over which the western section of the canal passes, is one of the greatest works on the canal.
—Cadwallader D. Colden, 1825

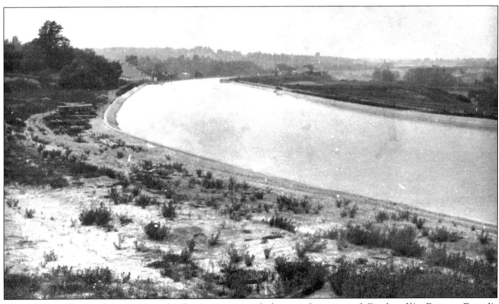

The Great Embankment was built just west of the settlement of Bushnell's Basin. Rand's Powder Mill, located in the hills near the basin, took advantage of the warehouses on the canal to ship blasting powder to customers. This picture, courtesy of the Perinton town historian, shows the Great Embankment as it looked in 1918. The large earth berm, which rises 65 feet from the floor of the Irondequoit Creek Valley, took over a year to build.

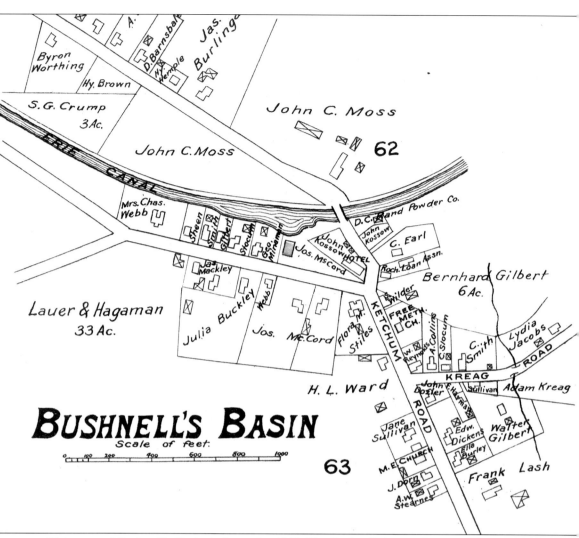

This map of Bushnell's Basin is from the 1902 *Plat Book of Monroe County*. This area was first named Hartwell's Basin after John Hartwell, who contracted to build the embankment. In 1823, William Bushnell of the real estate firm Bushnell, Lyman, Wilmarth & Company purchased 100 acres of the basin from John Hartwell. By 1825, the area was known as Bushnell's Basin. William Bushnell never lived in Perinton but was a very wealthy man by the time he retired in 1828.

Richardson's Canal Inn was built in 1818. Between 1821 and 1823, this tavern was known as "the West End of the Canal Tavern" because the Erie Canal terminated here before the Great Embankment was built.

This is an early stone warehouse on the canal, one of several warehouses built in the basin to store produce. For almost 50 years, Bushnell's Basin was a major destination for farm products shipped along the canal.

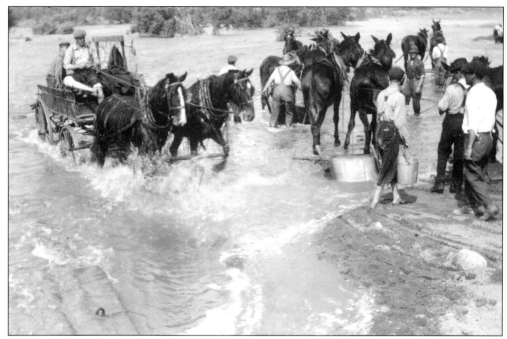

Major canal breaks near the embankment occurred in 1911, 1912, and 1974. This picture shows work being done shortly after the 1912 break.

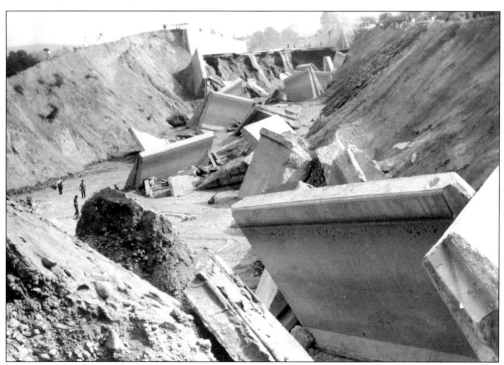

The 1912 reconstruction of the Erie Canal caused the collapse of a culvert under the canal, releasing thousands of gallons of water into the low-lying valley. This picture shows the aftermath of the September 3, 1912 break. On the left, workers are inspecting the damage.

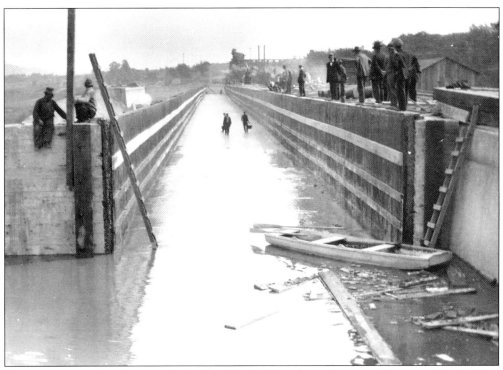

A temporary wooden flume was built after the 1912 break to take care of barge traffic while the break was being repaired.

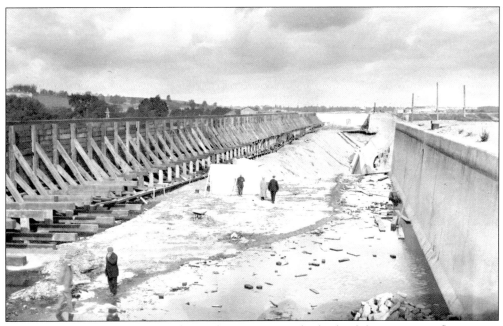

This picture shows construction being done in 1912. The back of the temporary flume is on the left.

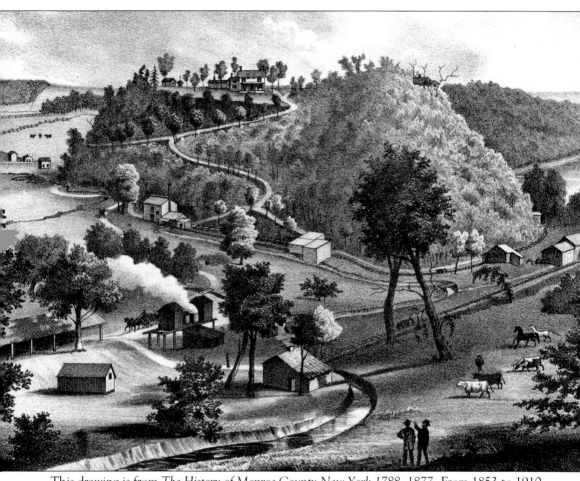

This drawing is from *The History of Monroe County New York 1788–1877*. From 1853 to 1910, Rand's Powder Mill operated in the hills just east of Bushnell's Basin. The owners, Mortimer Wadhams and Daniel Curtiss Rand, chose this stretch of hilly land because each building could be built apart from one another, so an explosion at one building would not set off the other buildings. The surrounding woods also provided the willow and soft maple trees needed for making the charcoal for blasting powder.

Four

Despatch, East Rochester

Despatch will become a great trading center and distributing point for a large surrounding district that must naturally pay tribute to her material wealth.
—Advertisement for the Vanderbilt Improvement Company

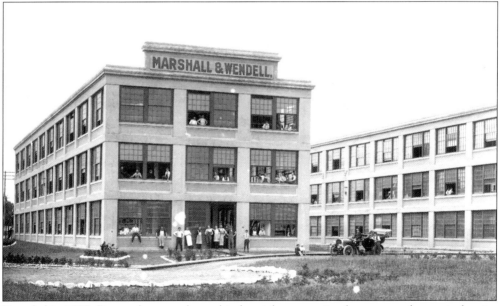

Founded in 1897, Despatch was a planned industrial community that attracted many industries to the area. Shown is one of a series of six reinforced concrete factories erected by the Foster and Armstrong Piano Works in 1904. The piano works shipped finely crafted pianos all over the world from this factory.

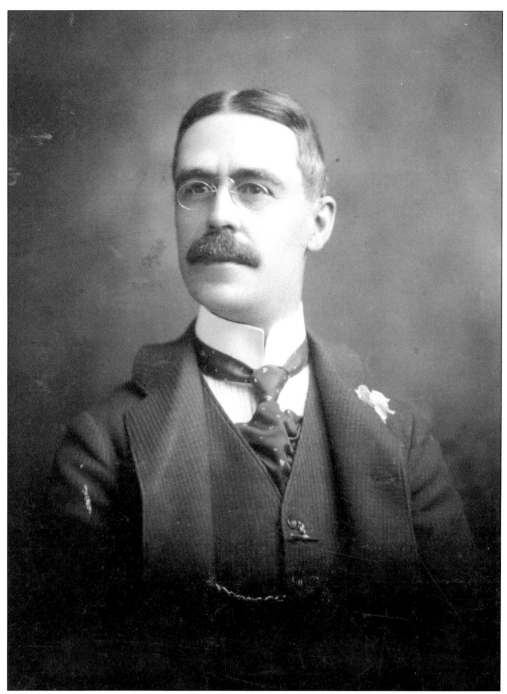

Walter Anson Parce (b. 1858) was a president of the Vanderbilt Improvement Company and founder of the village of Despatch. Through Parce's efforts, the Merchants Despatch Company was persuaded to relocate its car shops to the northwest section of Perinton. With investors Edward Lyon and Dean Alvord, Walter Parce created the Vanderbilt Improvement Company and began selling building lots, resulting in the residential community of Despatch.

By October 1897, the first of five car shops was completed. Special transportation by railroad was provided for workers commuting from the city of Rochester. This picture shows the office building, one of the car shop buildings, and the railroad cars that were constructed here in the 1900s.

This c. 1908 picture shows the lumberyard where thousands of board feet of wood were stored to be used by the Merchants Despatch Company to manufacture railroad cars.

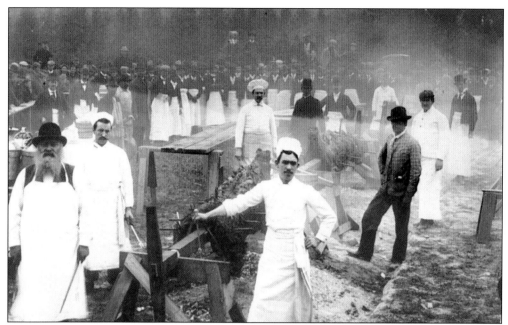

To help induce people to buy lots in the new community, the Vanderbilt Improvement Company organized a gala event with free food. On May 29, 1897, four 500-pound oxen were roasted and several hundred oversized loaves of bread were brought in for the 5,000 to 10,000 people who attended. This picture is courtesy of the East Rochester Local History Room.

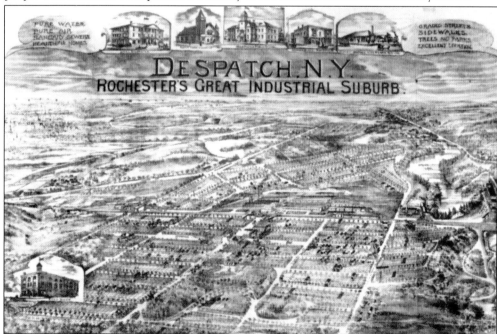

This early promotional map was made for the Vanderbilt Improvement Company. The roads were laid out in a grid pattern, with all the north-south streets named after U.S. presidents and all the east-west streets named after trees. This picture is courtesy of the East Rochester Local History Room.

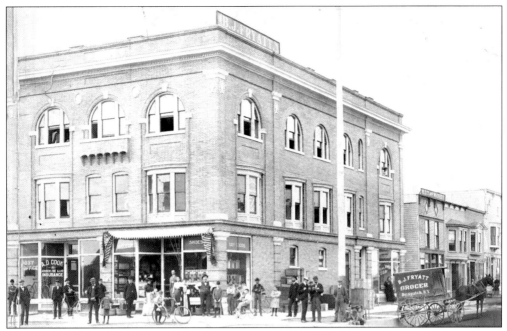

In September 1897, Burton J. Fryatt opened one of the first grocery stores in Despatch. He soon outgrew the space and asked Harry Eyer to build a large building block to house his expanded business. This photograph shows the Eyer building on the corner of Main and Commercial Streets. Mr. and Mrs. Fryatt are standing in the doorway, and Harry Eyer is the second gentleman to the left of the telephone pole.

This picture of Main Street shows, from left to right, the Despatch Hotel, the Fireman's Hall, and Kerrys Bakery. The streets were unpaved in the early days of the village. To help pedestrians navigate the bumpy muddy roads, railroad car doors were taken from the car shops and laid end to end as sidewalks in front of the buildings.

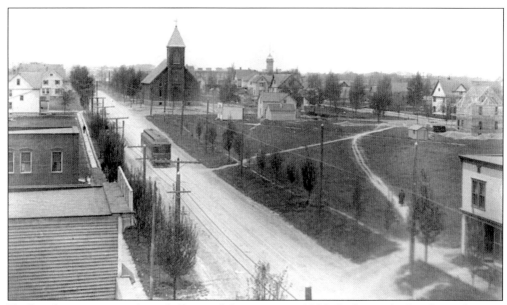

Trolleys began running through Despatch beginning in 1906. St. Jerome's church can be seen to the upper left. Village leaders wanted a more marketable identity for the village and, in 1906, Despatch was renamed East Rochester. By 1915, East Rochester was one of the fastest growing villages in New York State. This picture is courtesy of the East Rochester Local History Room.

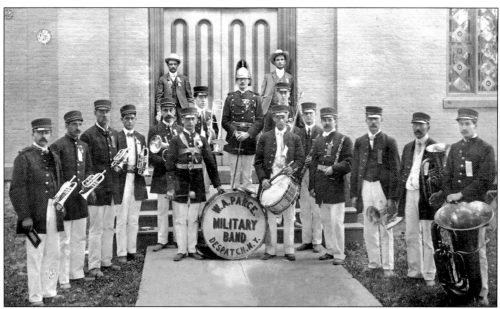

The W.A. Parce Military Band, formed c. 1902, played for many community functions.

Sewers were built in 1907 to accommodate the new indoor plumbing. This image shows the ditch-digging machine in front of the Eyer building.

In 1898, the Vanderbilt Improvement Company deeded the village two large lots on East Avenue to be used for a future school. The school, affectionately known as "the Red Building," had eight classrooms and was designed for 120 pupils.

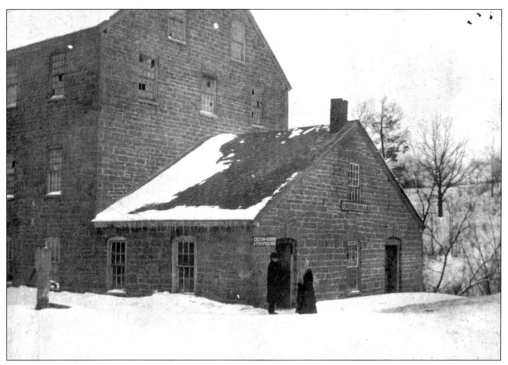

In 1821, Andrew Lincoln and Samuel Rich built a gristmill on what later became the eastern border of Despatch. The three-story mill, pictured here, was built of cut stone in 1847. It had three run of stones, two for flouring and one for custom work.

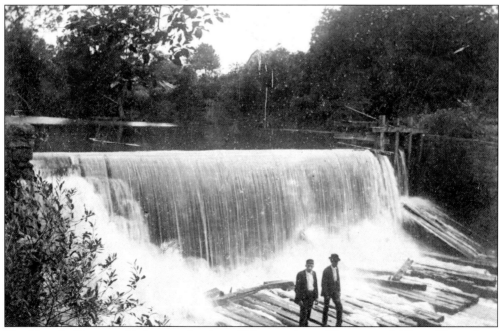

The Lincoln Dam provided power for the mill by creating a 50-acre pond. The mill was later bought by the Despatch Power and Light Company, which supplied power to the village of Despatch. In 1916, the dam burst and the mill was damaged beyond repair.

Five

DOWNTOWN FAIRPORT

Fairport is one of our most progressive suburbs. Ultimately it will be part of Rochester itself.
—The Union Advertiser, July 20, 1888

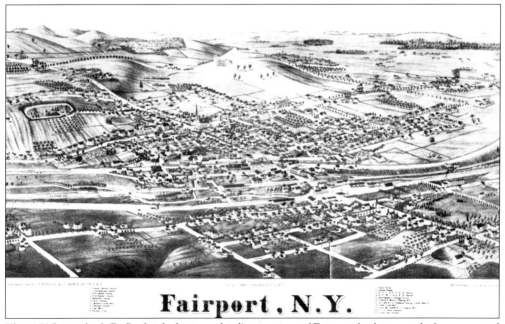

This 1885 map by L.R. Burleigh depicts a bird's-eye view of Fairport looking south. Incorporated in 1867, the beautiful countryside and hotel made this spot known to "canalers" as a "pretty fair port." The Erie Canal made Fairport the dominant community in Perinton.

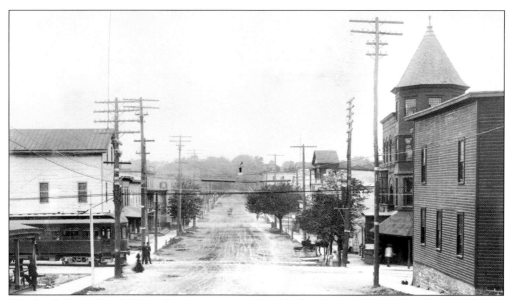

The land along North Main Street was swampland before being drained for the Erie Canal. Notice the electric light in the center of the street. The DeLand Chemical Works owned the first electric dynamo in western New York that was used for electric lights. Lights were only strung along North Main Street from the DeLand Chemical building to the owner's home at the corner of Whitney and North Main Streets.

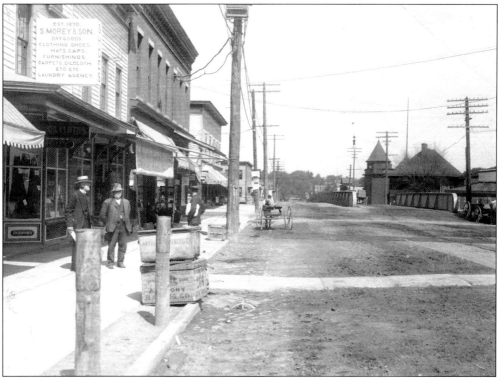

This c. 1910 picture of South Main Street looks north. To the right is the Main Street Bridge, which spans the Erie Canal. The Douglas Packing Company is on the right just across the bridge.

One of the oldest landmarks in the village is the former Fairport Hotel, which was built in 1827 by Cyrenus Mallet. For many years, it was known as Prichard's Hotel. Today it is part of the Millstone Block on the north side of the canal, at 9½ to 13 North Main Street.

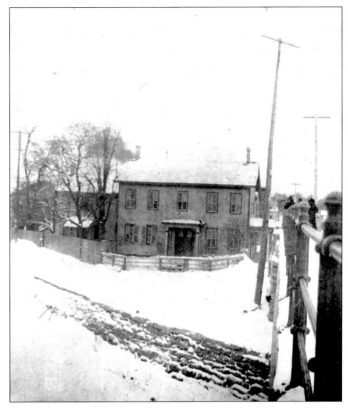

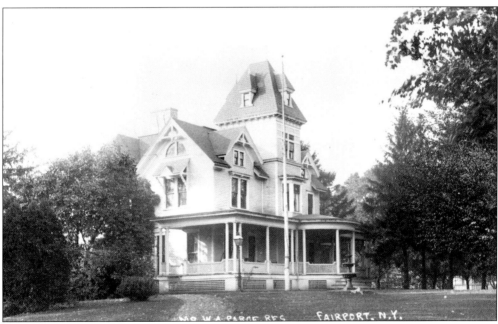

This early-1900 photograph shows the Walter A. Parce home on North Main Street. Built by William N. Newman, founder of Newman Baking Powder, the house had a large front porch and a beautiful fountain. It still stands at 137 North Main Street.

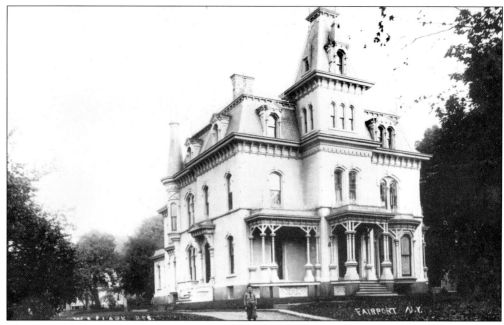

The DeLand House was built in 1876 or 1877 by Henry A. DeLand, son of the founder of the DeLand Chemical Works. After DeLand lost his fortune in Florida, the house changed hands several times. Today the building houses the Green Lantern Inn, located at 99 South Main Street.

Around 1912, the DeLand House was known as Villa Rosenborg. The house was named after the Castle Rosenborg in Copenhagen, Denmark, and had an extensive garden. Some 1,100 varieties of roses were grown in the gardens.

The Perinton Town Hall was erected on South Main Street in 1907. The village rented space for $350 per year. In 1931, the building was remodeled, enlarged, and sold to the village for $1. The auditorium was used as a theater from 1906 to 1920.

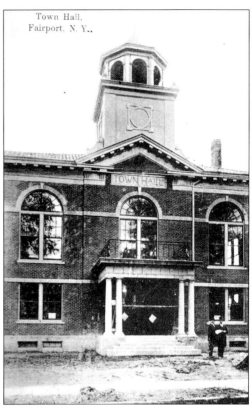

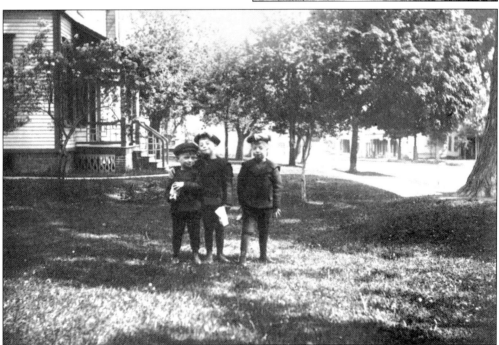

Three boys pose at 52 South Main Street c. 1900. They are, from left to right, Charles Wells, Franklin Wells, and Lynn Wells, grandchildren of W.P. Hawkins.

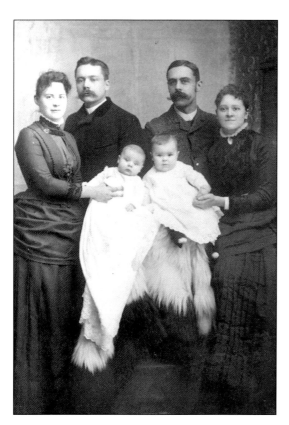

The Snow and Parce families, owners of the Snow & Parce Clothing Store, pose in 1886. Mr. and Mrs. J.H. Snow are on the left with their son Warren. On the right are Mr. and Mrs. Walter Parce with their son Donald.

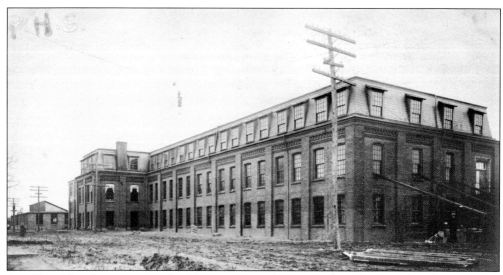

Cox Shoe Manufacturing moved to Fairport to avoid union strife in the city of Rochester. Shoes from this factory were sold all over the country. In 1888, the workers from this factory produced more than 3,000 pairs of shoes a day. The site was later occupied by the Sanitary Can Company.

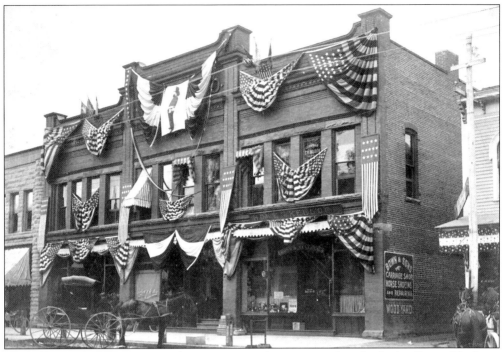

George G. Bown, a prominent businessman and carriage maker, built the Bown Block on South Main Street in 1890. This 1908 photograph shows the building decorated for Old Home Week.

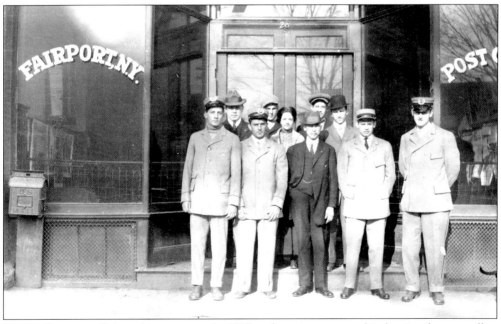

George Bown was Fairport's postmaster in 1897 and was instrumental in having the post office moved to his building. In this 1913 photograph, postmaster John Stebbins is standing in the front row, the third from the left.

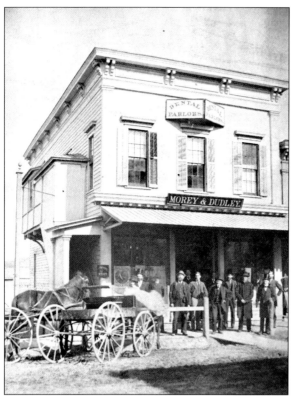

The Morey & Dudley grocery store was one of two stores owned by Smith Morey. This picture was taken in 1875. The building was located on Water Street in the village and was owned by Smith Morey and his partner, E.L. Dudley.

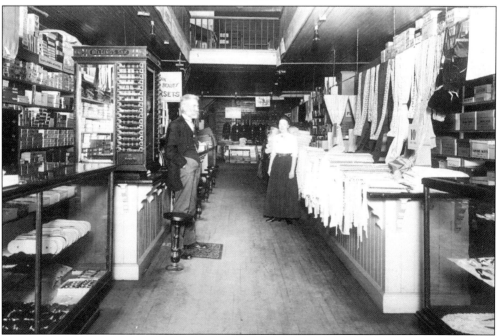

This is an interior view of S. Morey and Sons dry goods store on South Main Street. Joseph Morey, son of Smith Morey, ran the store until his death at the age of 80. Joseph Morey is pictured here with Alice Finnegan, a lifelong clerk.

A.C. Hooker's One Horse Grocery was one of several grocery stores in the village. This is an advertisement for Hooker's store at 21 West Avenue. Some of Hooker's products included One Horse Flour at 45¢ per 25 pounds, Warne's Yeast at 4¢, and a 2-pound can of roast beef at 20¢.

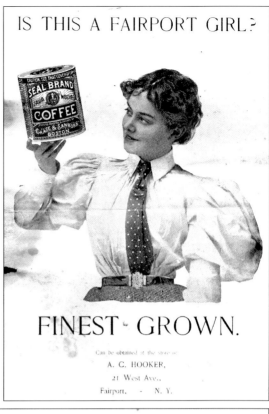

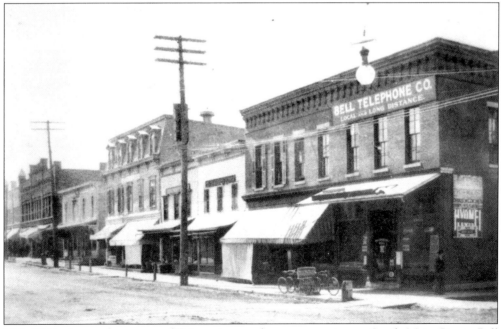

This 1904 picture shows one of Fairport's two phone companies on South Main Street. Bell Telephone was on one side of the street and Home Telephone was on the other. Stores in the village would subscribe to both services as a convenience for their customers.

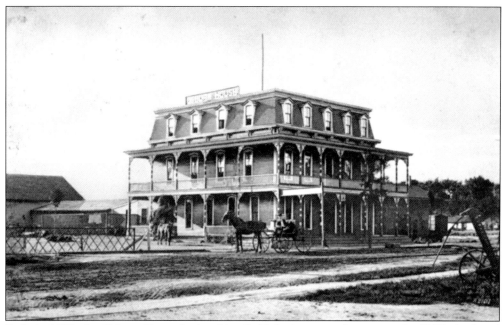

Built in 1870, the Osburn House had stables (left) for horses and carriages. In 1887, the hotel boasted of having steam heat and was lighted by electricity. The hotel was located on North Main Street between the two railroad lines that passed through the village.

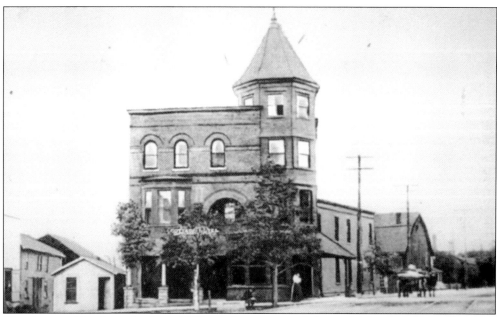

The Cottage Hotel was built in 1887 on the corner of John and Main Streets, across from the Rochester, Syracuse, and Eastern trolley station and near the New York Central Railroad terminal. The hotel was a popular stop for traveling salesmen who wanted a good place to eat or sleep.

Dr. D.G. Weare (1821–1890) was Fairport's resident philosopher, chemist, and physician. According to the *Union Advertiser* of July 20, 1888, "He puts up the best horse and cattle powder, guaranteed to purify the blood, clear out worms and recuperate a run down animal, like magic."

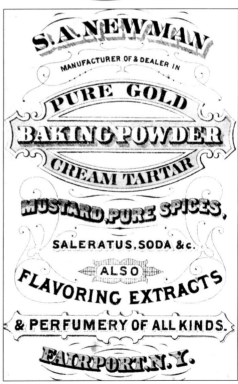

William Newman (1826–1902) purchased the W.J. Ayers spice and baking powder business in 1874 and established the Newman & Son Company. He later expanded his business to a large three-story building on North Main Street and renamed the business the Monroe County Chemical Company.

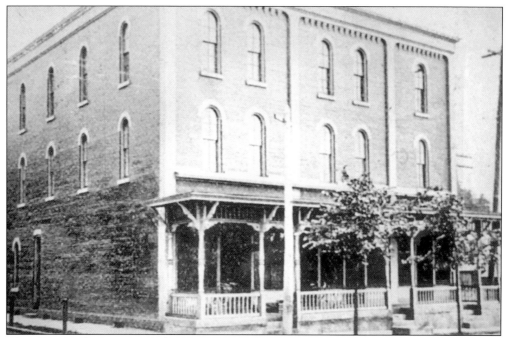
The G.C. Taylor Patent Medicine Depot was established in 1866. The business expanded rapidly and, in 1873, G.C. Taylor built this three-story factory on North Main Street, along the tracks of the New York Central Railroad.

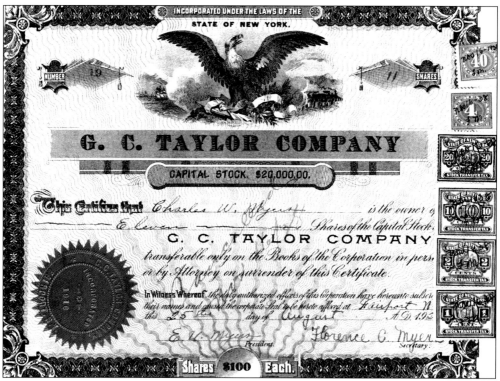
This is a stock certificate for the G.C. Taylor Company. Stock was sold from 1910 to 1939.

One of Taylor's best-selling product lines was Taylor's Oil of Life for Man or Beast. Shown here is a letter of endorsement from Buffalo Bill Cody, who used the product on his horses while on tour to Manchester, England, in 1888.

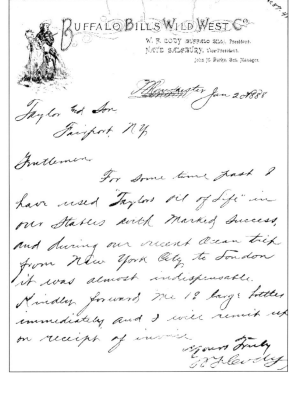

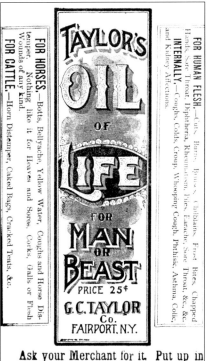

In 1929, the Federal Food and Drug Administration requested a change in labeling after questioning the curative properties of turpentine, an ingredient in Taylor's Oil of Life for Man or Beast. The product was renamed Taylor's Oil Liniment. In 1942, the G.C. Taylor Company was sold to Albert Van Wiegen and, by 1953, the company had gone out of business.

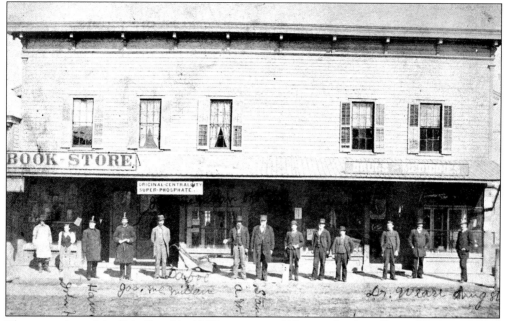

The expansion of the Erie Canal in 1912 was a mixed blessing for the village of Fairport. Many fine buildings were torn down to accommodate the wider canal. This picture shows the old Hawkins Block on the east side of South Main Street. The block was razed in 1912.

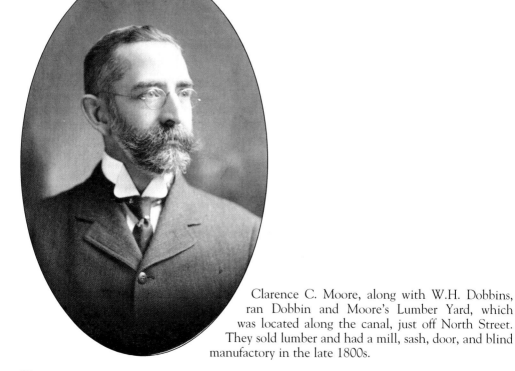

Clarence C. Moore, along with W.H. Dobbins, ran Dobbin and Moore's Lumber Yard, which was located along the canal, just off North Street. They sold lumber and had a mill, sash, door, and blind manufactory in the late 1800s.

J.K. Quakenbush was an early fire chief in Fairport. This photograph was taken by F.B. Clench, who operated a photography studio on the second floor of the Deal Block beginning in 1889. Clench's fine photography chronicled many early Fairport families.

This c. 1900 picture shows the Welch family. James Welch (front row, far left) became the mayor of Fairport, a dentist, and the Fairport village historian. Patrick Welch (middle row, third from the left) was the Fairport police chief in 1906 when the John Street fight broke out over the construction of a section of trolley track by rival companies.

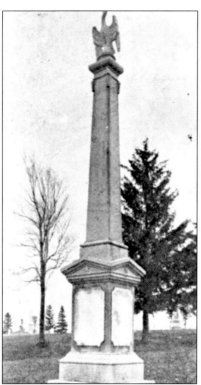

Mount Pleasant Cemetery occupies the highest point in the southern portion of the village. It was dedicated on September 13, 1865. In 1866, the town erected this monument to those who fell in the Civil War. Perinton sent 265 men to fight for the Union army during the war, 30 of whom have their names inscribed on the base of the monument.

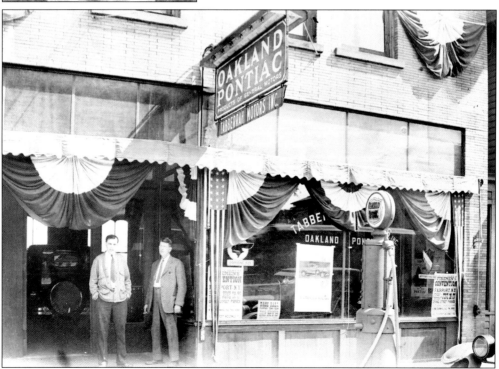

The age of the automobile saw the reuse of many older buildings for car dealerships and garages. This picture shows Taberrah Motors, a dealership at 38 West Avenue in the 1920s.

Six
DeLand's Chemical Works

Fairport owed, if not its actual existence, at least its increase and prosperity to one large industry.
— The *Rochester Union and Advertiser*, 1872, on the DeLand Chemical Company

This DeLand & Company letterhead illustrates the effect of industrialization on a country town. Started in 1852, the one-building company had, by the 1870s and 1880s, expanded to this conglomerate of buildings. The need for transporting raw goods and finished products was met by the company's position right on the Erie Canal.

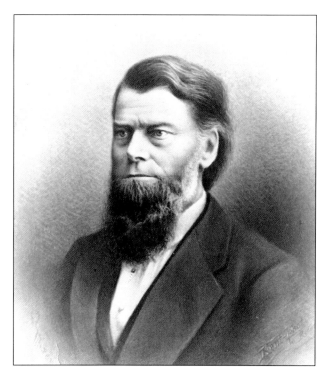

Before founding his business, Daniel DeLand, son of a Fairport farmer, led a varied life. At various times, he served as a cabin boy on a whaling vessel, a canal boat captain, and farmer in Wisconsin. DeLand and his wife settled in Norwich, where he served as an apprentice to his father-in-law to learn the process of manufacturing saleratus (an early form of baking soda).

Minerva Parce met Daniel DeLand when she was a passenger on his canal boat. She helped her husband open a "mom and pop" business in Fairport, first at home and then in a small building on the north side of the canal. While Daniel collected hardwood ashes from farmers and supervised the cumbersome process of leaching potash and saleratus from these ashes, Minerva and a helper packed the resulting product in paper bags.

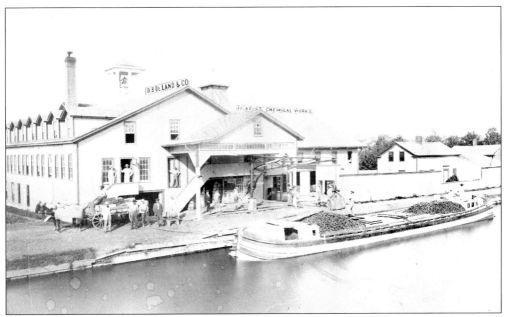

This *c.* 1860s picture is the earliest known photograph of the DeLand factory. Daniel DeLand is shown standing near the front of the loaded wagon. His office was at the top of the stairs under the projected roof. The bell in the cupola rang for the convenience of all the townspeople as well as the workers. It would ring at seven A.M. and at twelve, one, and six P.M.

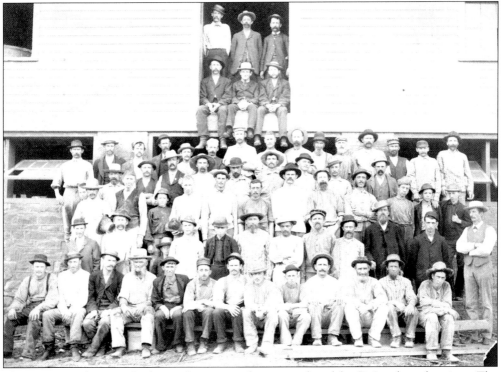

This *c.* 1882 photograph shows the range of ages employed by DeLand at the time. The company employed more than 100 workers, including the office workers and sales force.

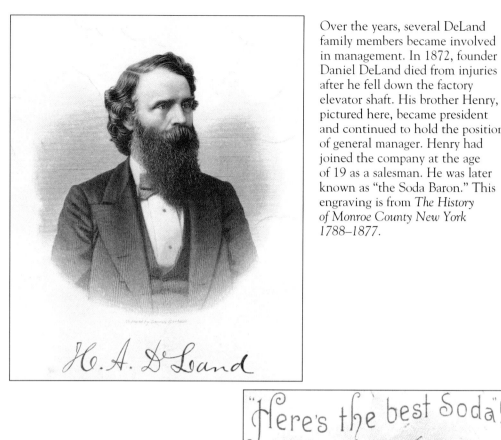

Over the years, several DeLand family members became involved in management. In 1872, founder Daniel DeLand died from injuries after he fell down the factory elevator shaft. His brother Henry, pictured here, became president and continued to hold the position of general manager. Henry had joined the company at the age of 19 as a salesman. He was later known as "the Soda Baron." This engraving is from *The History of Monroe County New York 1788–1877*.

Fairport businessmen claimed that Henry "sold more baking soda than any man alive." At the beginning of his career, he traveled nationwide. In time, he supervised a large corps of traveling salesmen. This card was left by salesmen in retail stores to be distributed to prospective customers.

In March 1877, the L.J. DeLand Steamer and Hose Company was organized and a constitution was written, the cover of which is pictured here. The document listed all the original members, including the president, Levi DeLand. Founding this organization was one way that DeLand married the needs of the community and the company. Fire was a potential danger to both.

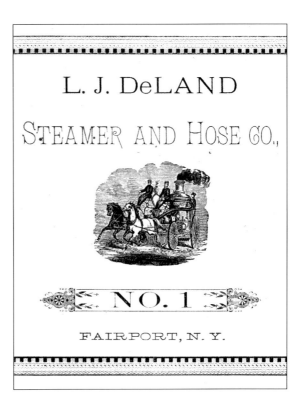

DeLand had become a household word throughout the country, competing with other companies as a result of quality, efficiency, and salesmanship. Levi Justice DeLand, Daniel DeLand's son, became a partner in the late 1870s. The company's name was changed to H.A. and L.J. DeLand and Company. In 1874, there were more than 100 workers and sales had reached $517,000.

The cover of this cookbook distributed by DeLand & Company shows a box of Cap Sheaf brand soda. A few females worked in the factory in the late 1800s. Fourteen or 16 girls packed 1-pound packages on the top floor of the building. One girl would fill the boxes and one would put on the label. The women earned about 45¢ for a seven-hour day, working five to six days a week.

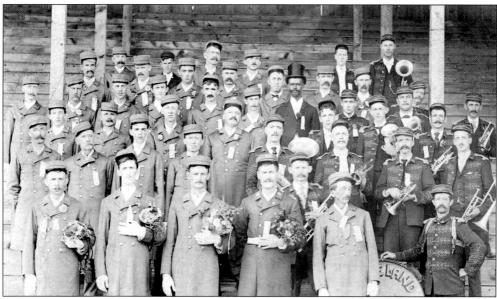

The DeLands were not only good businessmen, but also benefactors of the community. Daniel DeLand was appointed town justice in 1888 and was thereafter called "the Judge." Both he and Henry DeLand were active in politics and served on school boards and church committees. Levi DeLand formed the DeLand Hose Company. He also formed the DeLand Band, shown here at an 1895 concert given in Charlotte.

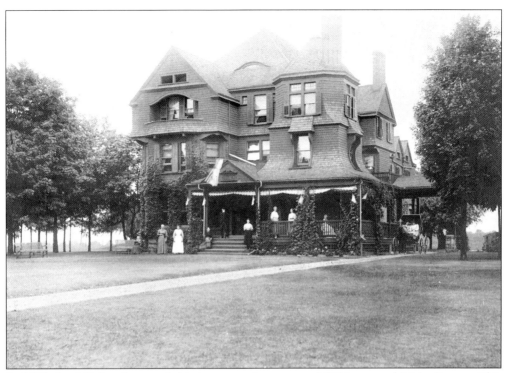

In 1888, Levi DeLand erected this house at the corner of Whitney and Main Streets. This large house stood on a 600-acre farm. After Levi DeLand's death, the Baptist Home of Monroe County purchased 20 acres of the farm and turned the building into an adult home, which is shown here c. 1906 with some residents.

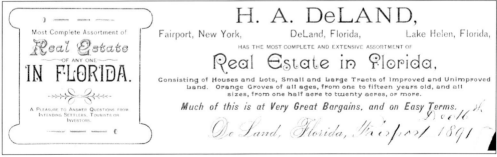

Henry DeLand bought property in Florida and began to promote this area and the growing of oranges to his friends in Fairport. This 1891 advertisement attracted many investors to the new community of DeLand, Florida. In the winter of 1896, a hard freeze destroyed the orange groves. DeLand felt obligated to repay investors and, at the age of 60, he returned to Fairport, took a position at the Monroe Chemical Company, and repaid all the investors.

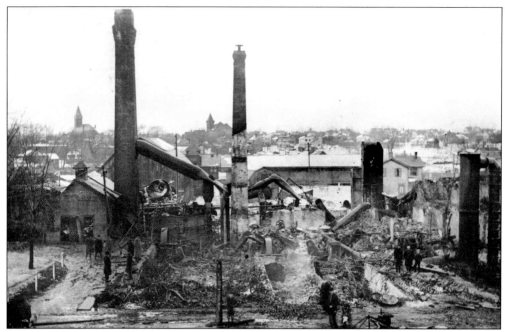

Shocked townspeople can be seen walking amidst ruined buildings of the DeLand Chemical Works. The fire was discovered by a worker on the morning of February 4, 1893. High winds and subzero temperatures impeded the firemen in their attempt to put out the fire.

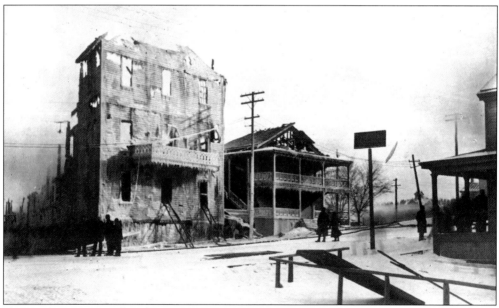

Shown the morning after the fire is the factory that faced Main Street, just across the street from Mallet's Tavern. By 1893, competition from other companies and the New Solvay Process, which used salt instead of ashes, were cutting into the DeLand Chemical Company profits. Attempts to reorganize the company were unsuccessful. After the death of owner Levi DeLand in 1904, the buildings were sold to the York State Fruit Company.

Seven
Cobb's Preserving, Sanitary and American Can

Sanitary Can Sealed without solder or acid.
—Slogan for the Sanitary Can Company

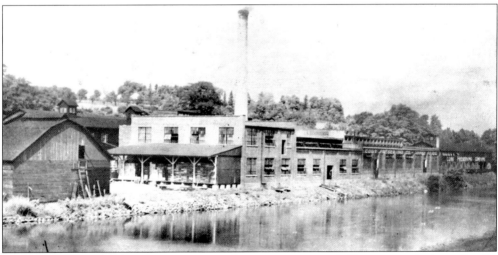

The rich farmlands and ready access to canal transportation made Fairport an ideal spot for the canning industry and played a major role in the development of Fairport and Perinton. A small canning company started by Ezra Edgett was purchased by Amos Cobb in 1881. His company, Cobb's Preserving (pictured here in 1900), became the Sanitary Can Company and later the American Can Company.

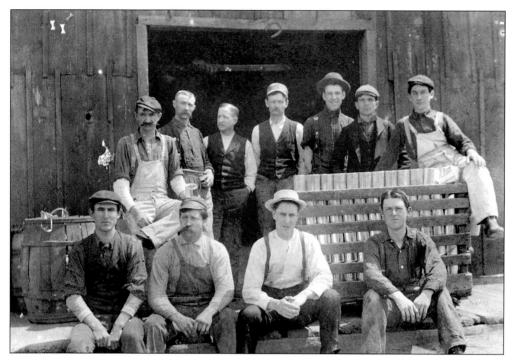

In the beginning, canning required that workers make cans by hand. Using tinsmiths' tools, they cut the body of the can with foot-operated shears and the tops and bottoms with foot presses. Each worker produced 100 cans in a ten-hour day. The salary of $2 per day was a large amount of money at the time.

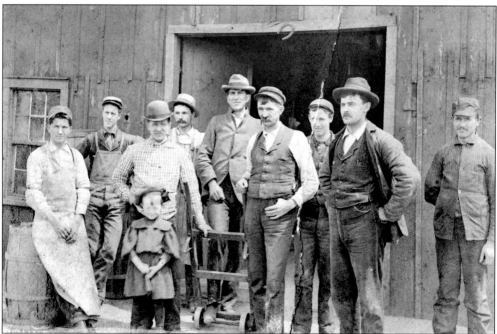

This is a group of workers c. 1897. By this time, a machine had been developed that would double-seam a tin plate and crimp it to the body of the can without the use of solder.

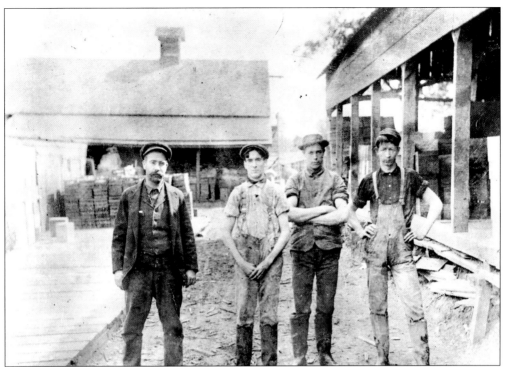

Cans for packing were made year-round by skilled workers such as the ones shown here. During packing season, temporary workers were hired from the surrounding area. In later years, Polish workers from Buffalo were brought in to can the fruits and vegetables for the company.

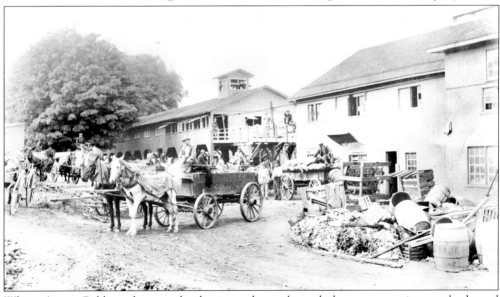

When Amos Cobb took over the business, he embraced the new canning methods and machinery of the Max Ams Machine Company of New York City. The results were mixed with many of the failed exploded cans dumped in the canal. Sometimes the cans exploded after being sold, causing consternation and accusations against the company. This photograph shows the plant *c.* 1902.

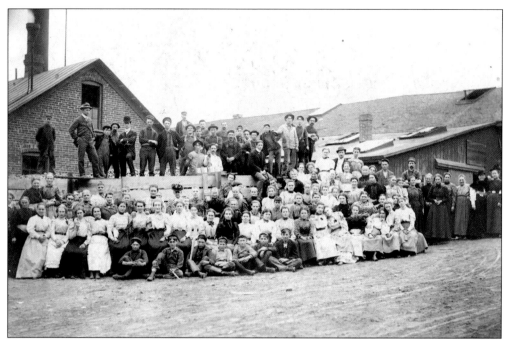

The former supervisor for Cobb's Preserving, Ananias Edgett, started his own factory—the Thomas Canning Company on Parker Street. The factory, built in 1896, was just across the canal from the Cobb factory.

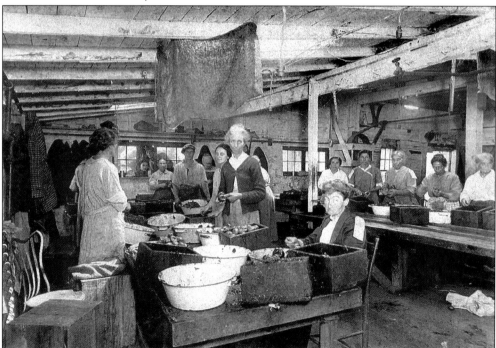

Working conditions were primitive in early canning plants. Shown is a group of workers at the Egypt Canning Company, which was later known as Comstock Foods. This photograph is courtesy of the Perinton town historian.

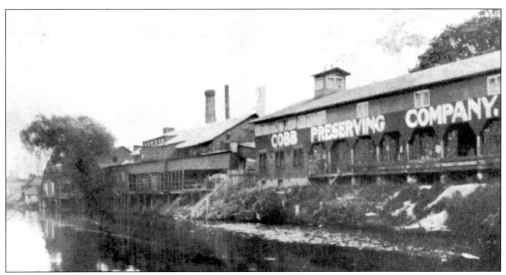

After 1881, the Cobb Preserving Company manufactured its own cans. By 1899, Max Ams machinery was installed and used until 1904, when the Cobb Company's can division was sold to the new Sanitary Can Company. This picture shows the old Cobb plant on the Erie Canal.

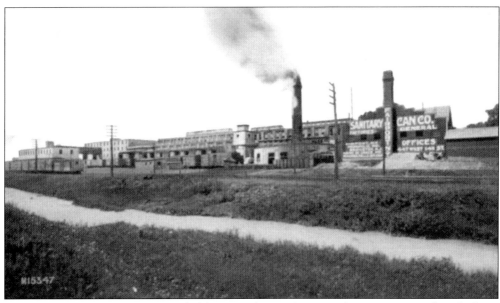

The Sanitary Can Company struggled for several years. In 1904, the company purchased a large plant near the railroad that had been used by Cox Shoe Manufacturing.

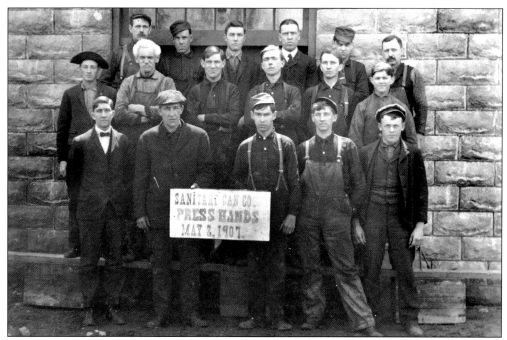
Shown in 1907 are some of the press hands of the Sanitary Can Company. The company struggled financially because it was unable to produce the 18,000 cans per day needed to make a profit. Also, leakage from cans cost the company $190,000 from 1907 to 1908.

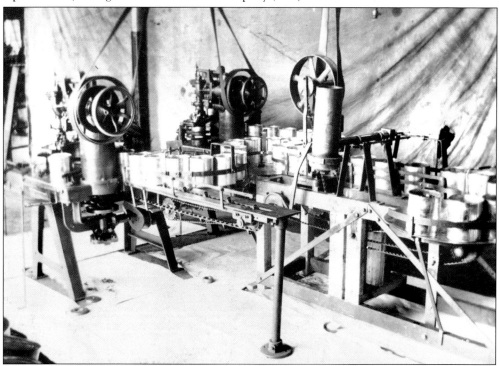
The company's early machinery required much of the work to be done by hand. At this typical workstation, the operator had to handle the can from start to finish in the manufacturing process.

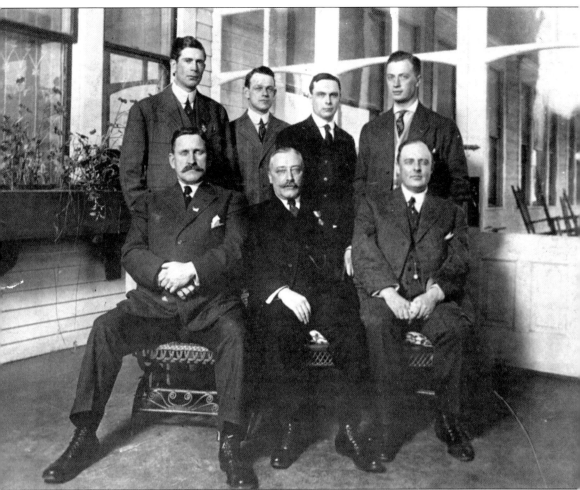

The development of the seamless can was eventually successful. The major players in this new process were known as "the ABC's of the Sanitary Can Company." They are pictured in the front row, from left to right, as follows: C. Max Ams, who developed the process and machinery for solderless cans; W.Y. Bogle, who was president and major financial investor in the company; and George W. Cobb, general manager and major stockholder. The men in the back row are, from left to right, Osean Day, unidentified, James Carurer, and Gordon Kellogg.

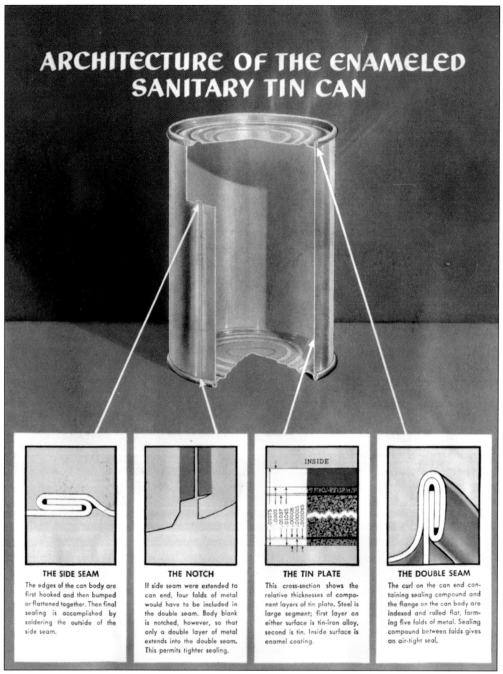

After the American Can Company acquired the Sanitary Can Company in 1908, improvements came rapidly. The above diagram illustrates some of the improvements that changed the world of canning. The manufacturing line became automated and the production of cans rose from 4,000 cans in ten hours to 350 cans a minute by 1971. This photograph is courtesy of the American National Can Company.

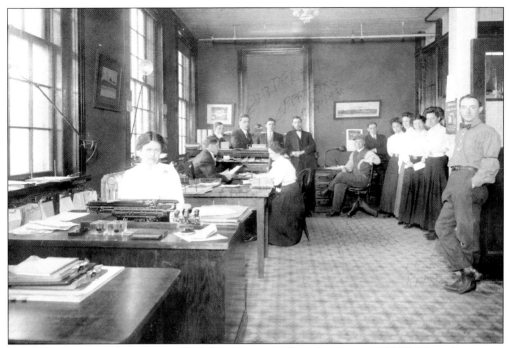

The picture shows the office staff of the American Can Company in 1915. Note the proper office dress and up-to-date equipment—the typewriter.

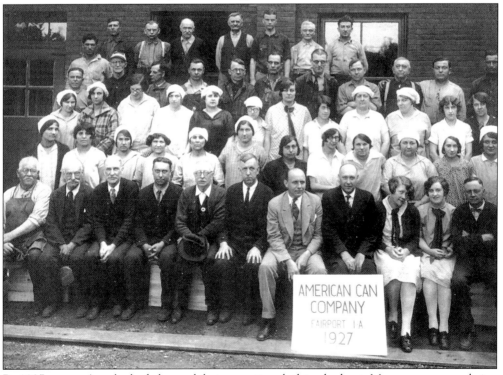

By 1927, women's styles had changed, but executive clothing had not. More women were being hired compared to the early years of the industry.

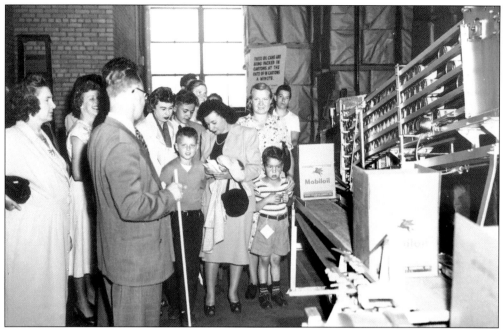

The American Can Company was a progressive company. It had a nurse for its employees and yearly family days. This tour in the 1940s is showing employees and their families one of the packing lines inside the factory.

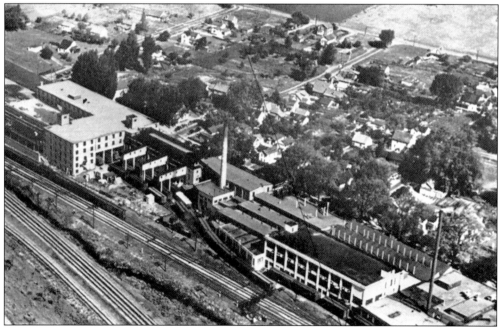

The year 1951 was the 50th anniversary of the American Can Company. In the late 1970s, the National Can Company of Chicago bought the company, and on December 15, 1993, the parent company moved the entire canning operation out of Fairport. The 400,000-square-foot factory is now used for storage and is also the home of Cantisano Foods. This photograph is courtesy of the American National Can Company.

Eight
VINEGAR TO CERTO

Do You Realize That Certo has revolutionized Jam and Jelly making: Cut the boiling time from 1-2 hours or more to just one minute; eliminated positively all failure.
—Certo promotion to retailers, 1920s

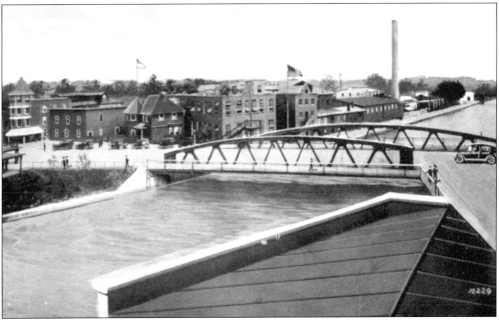

Even today, most people who make their own jams and jellies use either Certo or Sure-jell. The humble beginnings of these concentrated fruit pectins date back to three ambitious men who "knew their apples." Above is an early postcard of the Douglas Packing Company, forerunner of the Pectin Sales Company. This company, along with Cobb's Preserving and the Egypt Canning Company, made the area a major player in food preservation.

The York State Fruit Company, northeast of the canal on Main Street, was started in 1906 in the former DeLand Saleratus Works. The three founders—Earle Neville, John Clingen, and Robert Douglas—had previously served at the American Fruit Products Company as sales manager, office manager, and production manager, respectively. Douglas (1859–1929) was the son of a Scottish marmalade maker.

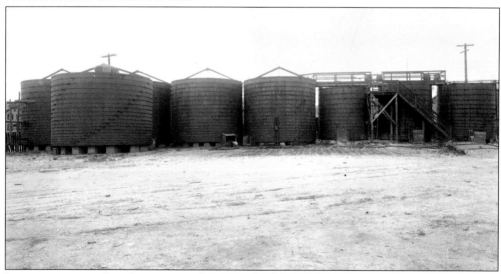
It was no surprise that the company became a leading producer of cider and cider vinegar in New York. Robert Douglas had invented a thermometer for making jam, worked in English food plants, and specialized in vinegar plants in the United States before incorporating with Neville and Clingen. Shown here are some of the numerous tanks at the plant, which stored vinegar made from the apples of local orchards.

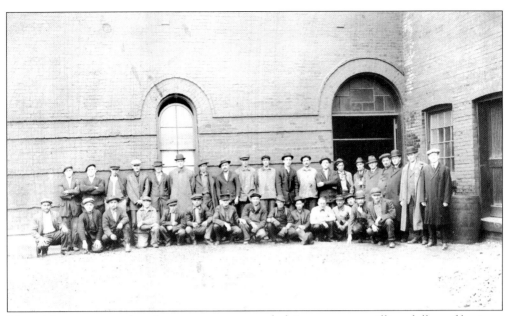

Many jobs were created as the company prospered, doing a quarter million dollars of business by 1912. Douglas was already on the trail of pectin, realizing it remained in the apple pomace from pressed apples. With chemist William Bender, he experimented with pectin to make jam. Years later, noting Douglas's leadership and drive, Bender wrote that Douglas "towered over all of us like a pillar of fire."

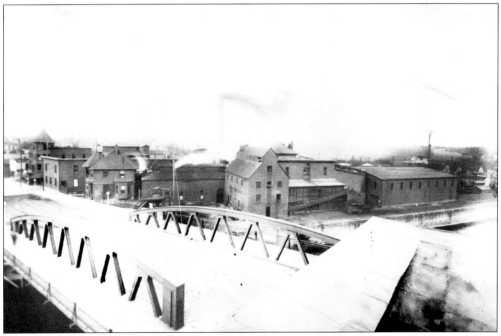

In 1911, Douglas, Neville, and Clingen were joined by Charles Douglas, Robert Douglas's brother, and John Ellithorp of the Beech-Nut Packing Company. They formed the Douglas Packing Company, pictured here, to control an emerging pectin business that took advantage of the location's shipping facilities and its fruit-growing productivity.

John J. Clingen was the production manager and later the treasurer for the Douglas Pectin Corporation. Clingen and his wife, Blanche, lived on the west corner of West Church Street and Potter Place.

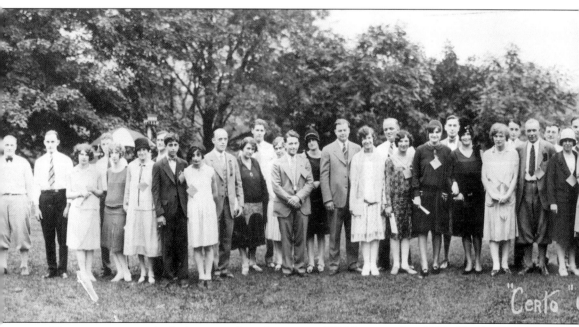

The company organized picnics, such as this one at Old Homestead in 1928. Charles Douglas,

Even on its stationery, the Douglas Pectin Corporation showed how easy and fast it was to preserve jams and jellies using Certo: "10 o'clock boiling started using CERTO…1 minute later Boiling finished…15 Minutes From Start Work done-jelly in glasses and sealed." This letter is from the company's sales department, located in the city of Rochester.

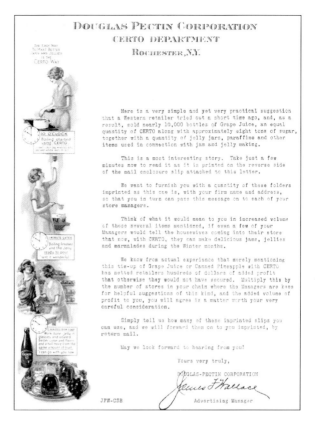

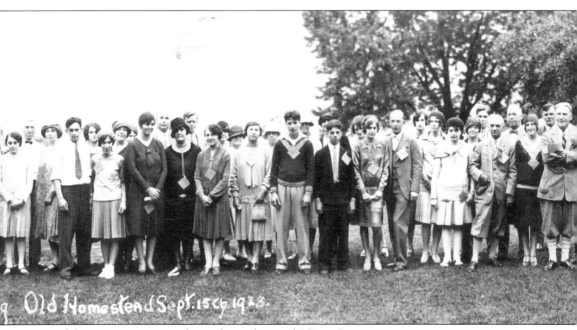

one of the owners, is pictured just above the word "Certo."

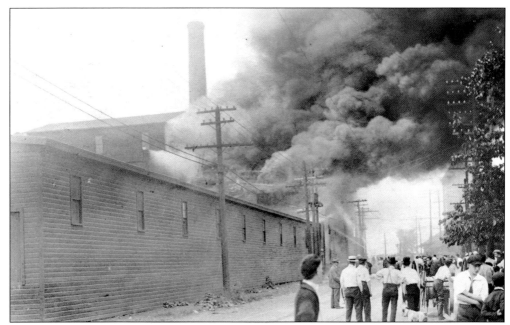

A fire at the Certo factory on July 16, 1916, was extinguished before it gained much headway. Another fire on September 27, 1921, was more severe, causing more than $300,000 in damage. It was called the worst fire in Fairport's history.

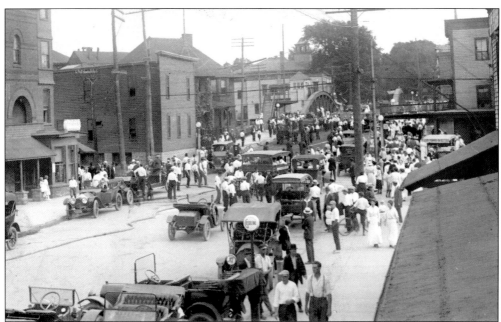

A local newspaper reported that "the buildings of the plant and the streets adjacent were alive with fire fighters and spectators." This picture looks south on North Main Street. The factory is on the left, just before the bridge. In 1946, the Certo operation was moved to Albion, New York. Today, Certo is manufactured by General Foods, a division of Philip Morris.

Nine

CRYSTAL SPRINGS WATER

Crystal Rock Mineral Spring Water is admittedly the King of Table Waters and Nature's Sovereign Remedy.
—A company advertisement, 1889

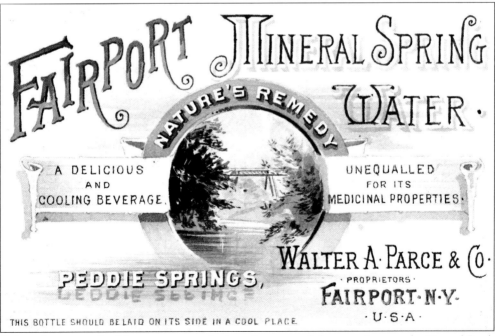

Riding the wave of public acceptance of mineral water and therapeutic spas, the Crystal Rock Water Company was created in 1890. The spring water's high mineral content and therapeutic qualities made it the favorite among local and national consumers.

In the summer of 1885, Dr. John Peddie, a Baptist minister from Philadelphia, was introduced to the bubbling springs by a local hunter. Recognizing the water's curative powers, Dr. Peddie began selling the water to the local public. He later married Fairport-born Molly Wilson.

The land was acquired by Dr. Peddie, cleared of the underbrush, and several springs were located. This picture shows the springs before buildings were built to protect them. The area became known as "Peddie Springs."

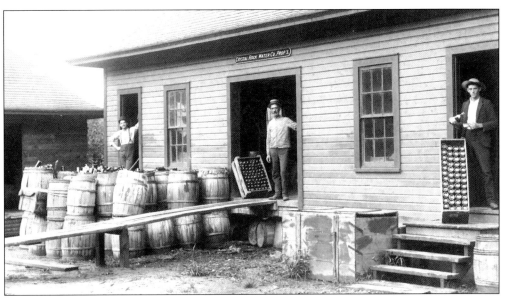

By 1889, buildings had been erected, and the water was being sold to consumers in bottles and barrels. Shown here are barrels of bottles outside the loading dock. The bottles were returned by customers and reused by the company.

Crystal Rock Water Company,

INCORPORATED APRIL 19, 1890.

No. 9 Twenty-One Shares.

Capital $20,000. Shares $100 Each.

THIS IS TO CERTIFY, that *Walter A. Parce* is entitled to *Twenty-One* fully paid up Shares of the Capital Stock of the CRYSTAL ROCK WATER COMPANY, of Fairport, Monroe Co., N. Y., transferable only on the Books of the Company, in accordance with the By-Laws of said Company, in person or by Attorney, on the surrender of this Certificate.

WITNESS The Seal of said Company and the signatures of the President and Treasurer.

Fairport, N. Y., *November 13th* 1890

Levi J. DeLand President.

Joseph H. Snow Treasurer.

The company was incorporated in 1890 and became known as the Crystal Rock Water Company. This stock certificate was issued to Walter Parce, who became a major promoter of the enterprise. Levi DeLand, Parce's uncle, was president of the company, and J.H. Snow, Parce's business partner, was treasurer.

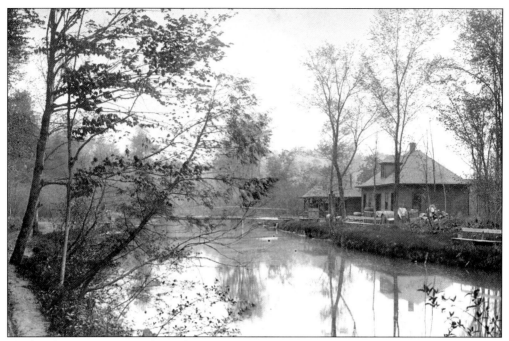

The bottling operation was located on a scenic 17-acre site on a bend in the Irondequoit Creek. The company was just 1.5 miles west of the village of Fairport, where the Crystal Springs subdivision now stands.

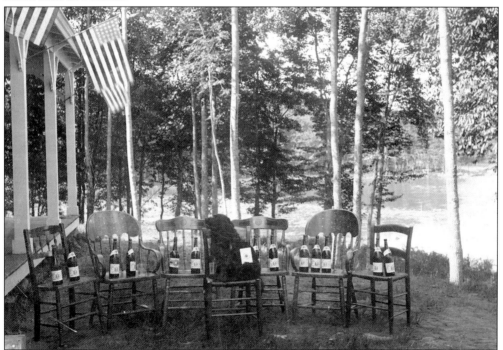

Peddie Springs was not developed as a tourist resort, but the grounds did have a pond, a pavilion and a public grove used by local residents. This is a promotional photograph taken in front of the pavilion.

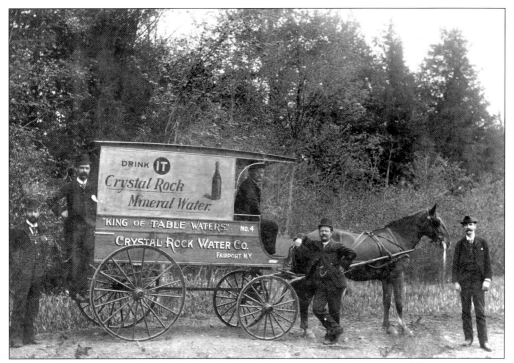

The water could be obtained in glass bottles, stone jugs, or barrels. It was sold in pints, quarts, and gallons throughout the country. Local delivery was made by horse and wagon.

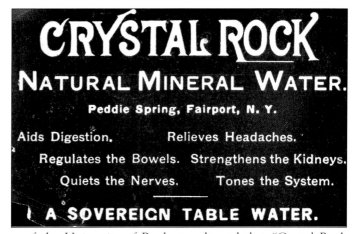

An analysis by Paul Lattimore of the University of Rochester showed that "Crystal Rock Mineral Spring Water is nearly double in valuable mineral qualities the strongest water yet discovered." This price list and trade card date from c. 1890.

A testimonial by a local doctor, D.G. Weare, on February 15, 1889, proclaims, "The water of Crystal Rock Spring is not only a delicious beverage, but from its analysis must be a very valuable medical agent especially in the chronic ailments of the stomach, liver and kidney. It is destined to become the favorite mineral water of the world."

Ten

COMMUNITY ACTIVITIES

There are no flies on Fairport people.
—The Union and Advertiser, 1888

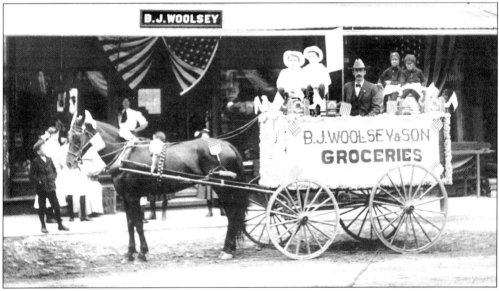

Fairporters of the late 1800s and early 1900s kept themselves involved with their community. Small town life afforded the luxury of having movie theaters, libraries, parades, picnics, plays, and other recreational activities. Some people spent their time improving the quality of life in the village by writing books, painting fine art, organizing theater productions, and collecting local history documents. This photograph shows the B.J. Woolsey & Son float for a parade held on August 3, 1908. Ray Woolsey is the driver.

The first library in town was a subscription library started by Julia Dickenson, pictured here. Books were loaned by buying tickets. The tickets could be obtained for $1 a year, 50¢ for six months, or 25¢ for three months. Notices for overdue books were published in the local paper.

The library was located on the second floor of the Dickenson House. Built in the early 1800s at Fullamtown on the Erie Canal, the house was moved to East Church Street in 1850.

The Fairport Library was chartered by the State of New York in June 1896. The library buildings themselves were located in various parts of the village of Fairport over the years. In 1935, the library was located in this home at 18 Perrin Street.

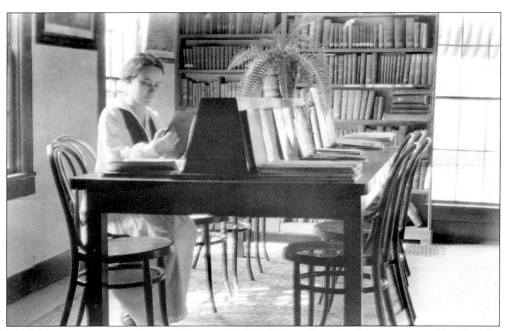

The library soon outgrew the small house. In 1930, Robert Douglas, former owner of the Douglas Packing Company, left 500 shares of General Foods stock in his will to build a new library.

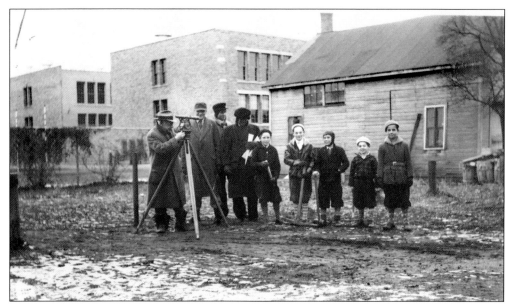

The Douglas donation and funds from the Patriotic League supplied the seed money to hire local architect Henry Martin to draw up a plan for the new library. This picture shows engineer George Weeks surveying the library lot with a group of youthful onlookers.

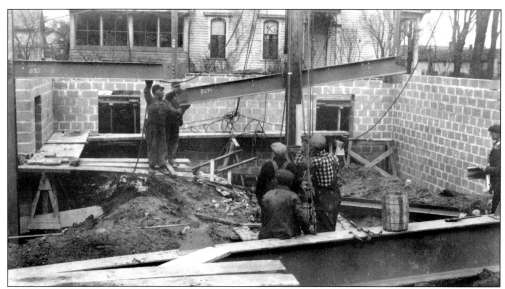

Construction on the library began in 1936 as a Works Progress Administration project. In this photograph, the old library has been razed and workers are the setting the first beams for the new building.

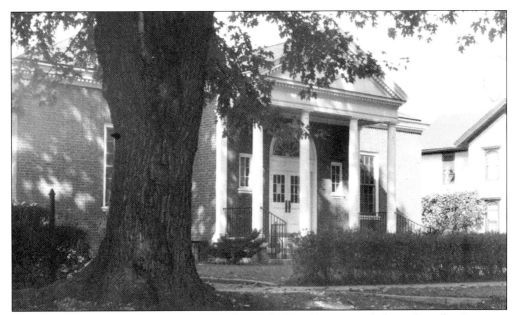

The library building was formally opened March 5, 1937. It was dedicated to the Perinton veterans of World War I. In 1979, the Fairport Public Library moved to the Village Landing. The building now houses the collections of the Perinton Historical Society and is known as the Fairport Historical Museum.

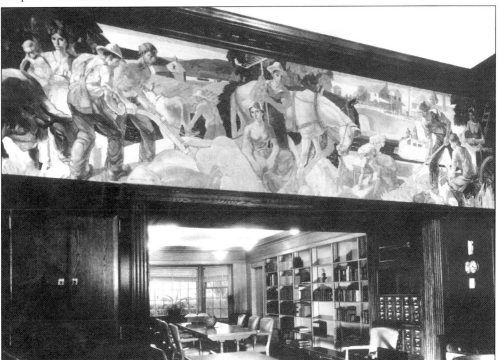

The mural commissioned for the new library was painted by artist Carl W. Peters in 1938. This Works Progress Administration project depicts the agrarian roots of Fairport and Perinton as well as the Erie Canal.

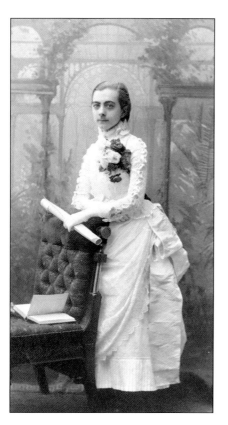

Helen DeLand, shown here as a Fairport High School student in 1886, was the daughter of Henry A. DeLand. She was also a librarian, teacher, and author of the book *The Story of DeLand and Lake Helen, Florida*.

Majorie Snow Merriman was the charter member and cofounder of the Perinton Historical Society in 1935. Her work as collector, historian, and genealogist left a legacy of historical data to the people of Perinton.

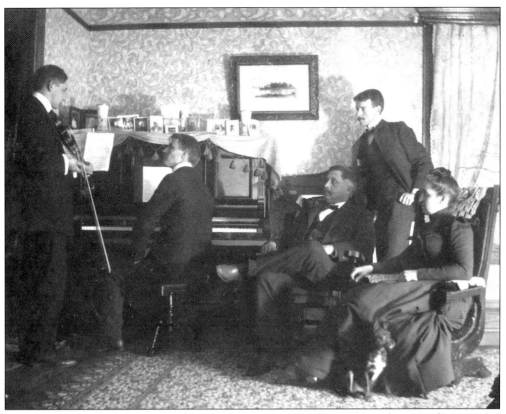

This was a common scene in the early 1900s, as people would gather together to play music. Wade Becker and Ed Moore are shown here entertaining at the Beckers' home on Perrin Street.

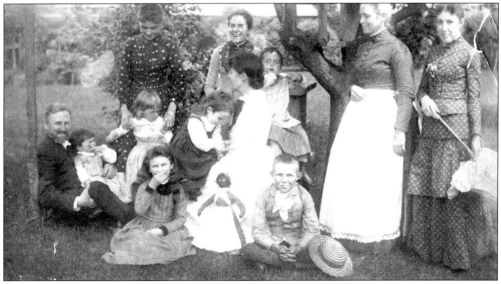

This c. 1890 picture shows a group of friends meeting on the Dickenson property, located behind the Congregational church.

Charlotte Howard of Salter Brothers Nursery is dressed up here in chrysanthemums for the Business Carnival in October 1894. A note on the back of this picture reads,

At Salter Brothers, so I've learned today,
You can feast your eyes on a gorgeous array,
As Thanksgiving approaches you may pay a small sum
And procure the popular chrysanthemums.

The first automobile in Fairport was the 1905 Ford owned by Fred Potter. The driver is William Beeton. Potter is seated in the back seat. The picture was taken in front of 72 West Church Street.

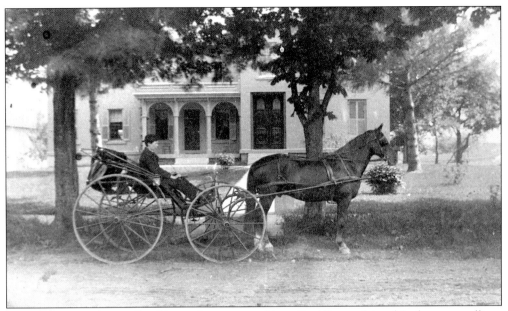

Potter maintained a small stable on the property. Here, Fred Potter drives his chestnut stallion, Maude, in front of his home. This is an early picture of the house before the front porch was added.

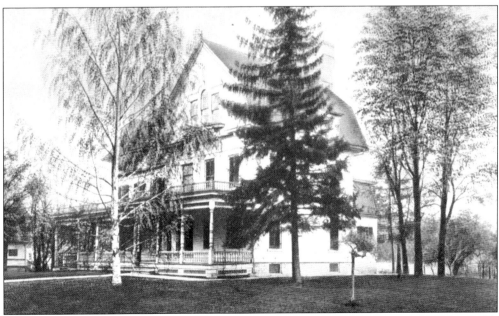

The Potter House, located on West Church Street, was bought by Henry Potter in 1872. Henry's investments in Western Union Telegraph made him a fortune. The house was left to his son, Fred Potter, who died in May 1943 and left the building to the village. It was later converted into a community center.

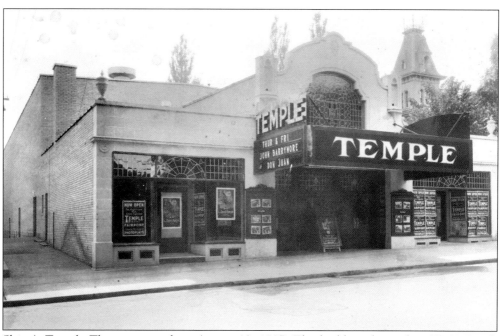

Shine's Temple Theater opened on August 12, 1927. The building, located at 85–89 South Main Street, is of brick construction and contains five fire exits. At the time, it was considered one of the safest theaters in the country.

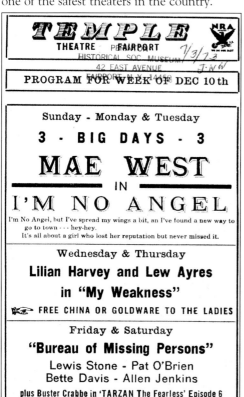

In the 1930s, the theater would change movies as often as three times a week. Incentives such as free china were often used to bring people into the theater.

Shaw's Hall, sometimes called "Shaw's Opera House," was the largest meeting place in town, seating 450 people. The original building that moved to West Avenue in 1854 was enlarged in 1868 by attaching another building and constructing a second story. This picture shows the building when it was known as the Rivoli Theater.

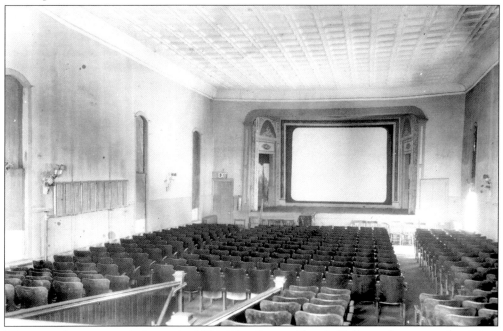

Silent movies came to Fairport in 1906. The former Shaw's Hall was known as the Bijou, the Bijou Dream, and finally the Rivoli. The small stage, seen here, was also used for stage productions. The entrance can be seen in the center of the theater.

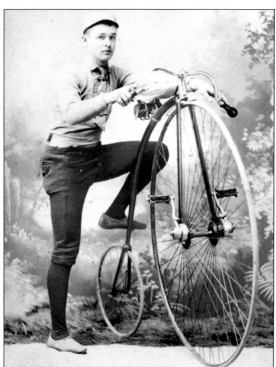

Lee Hazen, son of longtime railroad station agent A.E. Hazen, poses here with his "high wheeler" in the late 1890s.

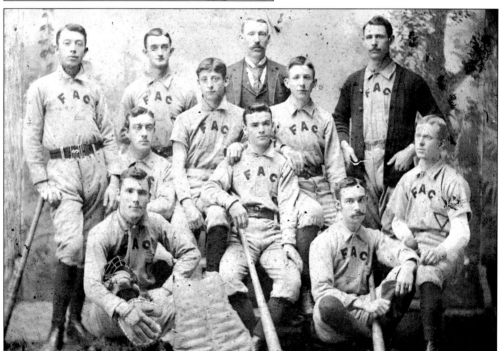

Pictured is the Fairport Athletic Club YMCA baseball team. The players are, from left to right, as follows: (first row) unidentified and George Mulliner; (second row) Clarence Green, unidentified, and Wales Dixon; (third row) Dennis Dougherty, and S. Fagan; (fourth row) Will Butcher, Frank Hardick, John Dixon, and unidentified.

The play *The House of Epimetheus* was performed by the Iantha Club at the YMCA in 1893.

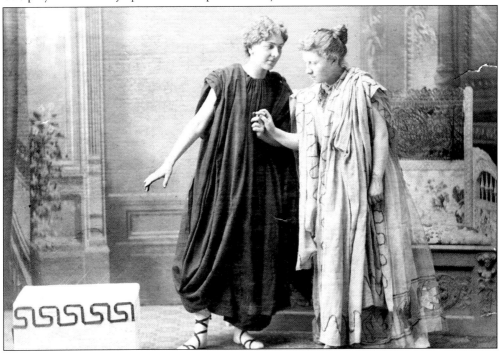

In this scene, Epimetheus, played by Nellie Dunbar, pleads with Pandora, played by Fanny Anery, not to open the box left by Zeus: "The Oracles forbids. Seek not to know what they have hidden from thee."

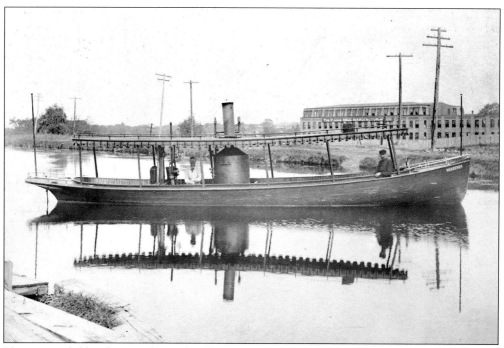

Pleasure craft like the *Wanderer* often had to share the canal with working barges. The Cox Shoe Manufacturing building can be seen in the background.

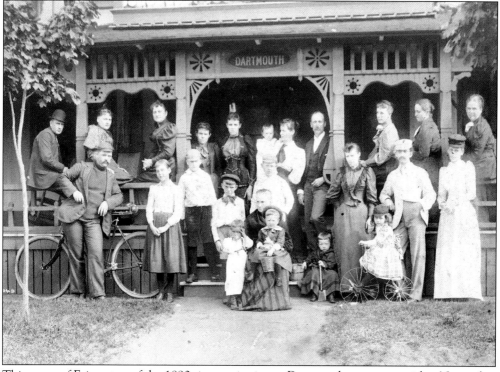

This group of Fairporters of the 1890s is vacationing at Dartmouth cottage, at either Nantucket or Martha's Vineyard.

Eleven
CHURCHES, SCHOOLS, AND ORGANIZATIONS

I call that education which embraces the culture of the whole man, with all his faculties-subjecting his senses, his understanding, and his passions to reason, to conscience and to the evangelical laws of Christian revelation.
—Quote from DeFellenberg from *The School* by Alonzo Potter, 1842

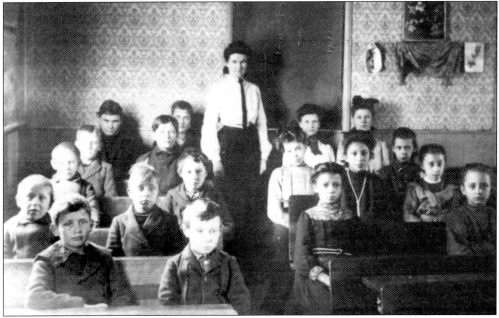

A sense of pride and community in Fairport has always been expressed through its schools, churches, and organizations. This c. 1908 picture shows the schoolchildren of Perinton School No. 3. Emma Fisher is the teacher.

The Classical Union School was built in 1870 on West Church Street in the village. The first graduating class was in 1876. Graduates from that class included Mollie Hill, Ella Lewis, Charles Watson, and Charles Waldron.

Prof. A.S. Downing was the principal of the Fairport schools from 1882 to 1886.

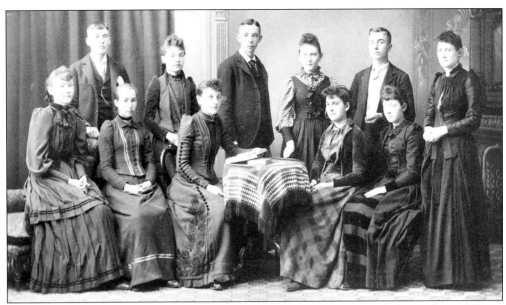

Members of the Fairport High School graduating class of 1891 are, from left to right, as follows: (front row) Adelaide Sullivan, Nellie Dunbar, Julia Scribner, Lillie Prichard, and Mina Van Ness; (back row) George McAullife, Dace Murdoff, Milton Gater, Pearl Knapp, Clarence Blood, and Julia Kennedy.

New York State Education Department

63 Count Certificate

Fourth Academic or Twelfth School Year

Whereas the *Principal of* Fairport High School *has certified to the New York State Education Department that in examinations held by its appointment* Ja. '07

Irmagard L. Burns

now holding the preliminary certificate, has completed the examinations required for advancement; and

Whereas *the answer papers on review at this office show an attainment of the indicated percentages in the following subjects:*

English 88, English 2nd 91, German 1st 97, German 2nd 95, Latin 1st 96, Caesar 85, Cicero 92, Latin prose 90, Algebra 98, Solid geometry 94, Physical geography 93, Geology 77, Physiology 93, Greek history 81, Roman history H, Am. history 97, Civics 98, Com. geography 98, Drawing, Adv. drawing 75, Pl. geometry, Chemistry 1 & 2, 96.

Therefore *be it known that when this certificate is validated by the Principal's signature it is to be accepted by all institutions of the University of the State of New York for the subjects designated above.*

Edward J. Goodwin
Second Assistant Commissioner of Education

No. 198 *on the school records*
J. M. Gast, *Principal*

Subjects such as Greek and Roman history, physiology, and Latin prose were common in schools around the turn of the century. Fairport High School was no different, as this 1907 report card can attest.

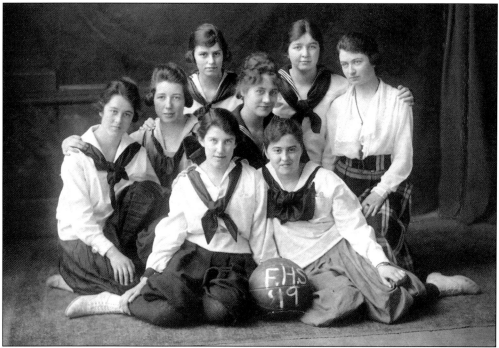

The Fairport High School girls basketball team of 1919 poses in full uniform.

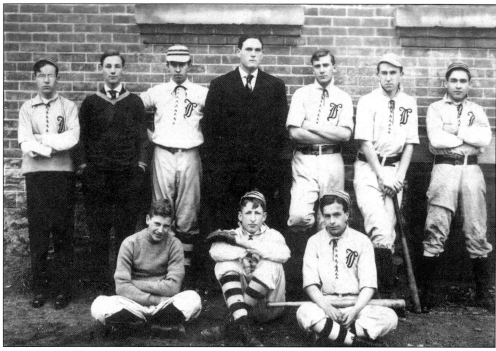

In 1907, the Fairport High School baseball team won the county championship. The team members include, from left to right, the following: (front row) R.H. McBride, J.W. Welch, and Roy Simpson; (back row) Leon Simpson, J.D. Emery, Ray Worthing, Dan Mellen, Harold Brainard, Clinton Raymond, and Howard Baumer.

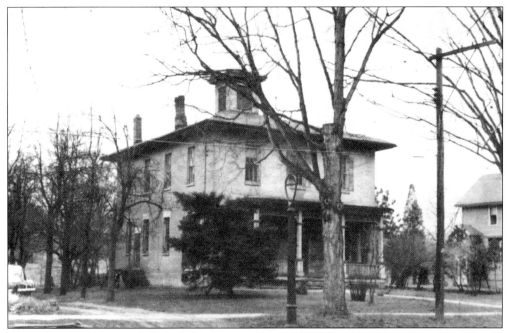

This school building was built in 1855 and served as a school until 1870. It was on East Church Street and was used as a boardinghouse for teachers from 1870 to 1951.

The West Avenue School was built on the playing fields of the old Union School in 1924. It contained 60 rooms, including a gymnasium and an auditorium that seated 750 students.

Minerva Lewis DeLand, an 1894 Fairport graduate, attended Vassar in 1899 and graduated from the Albany Normal School in 1900. She came back to Fairport High School and taught Latin and later became principal. One of Fairport's schools is currently named after her.

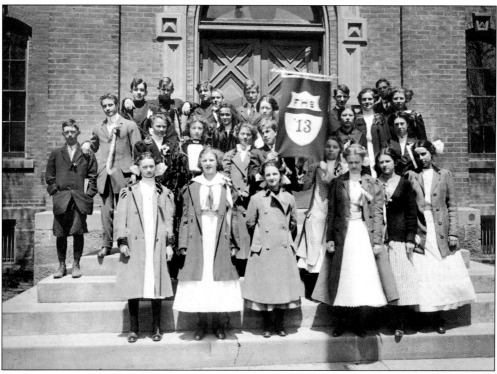

The Fairport High School graduating class of 1913 poses outside of the old Union School. Only 26 graduates are pictured here. Over the next ten years, however, the Fairport School District more than doubled in size.

Known as the Northside School, this grade-school building on East Avenue in the village was erected in 1886. In 1960, the Crosman Arms Company purchased the building and transferred the deed to the Village of Fairport for educational and recreational use.

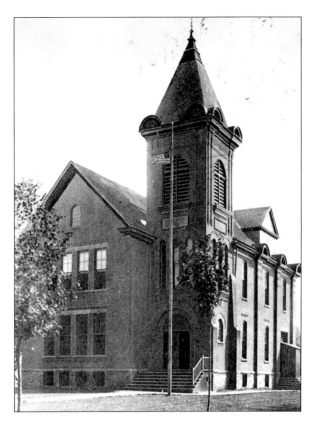

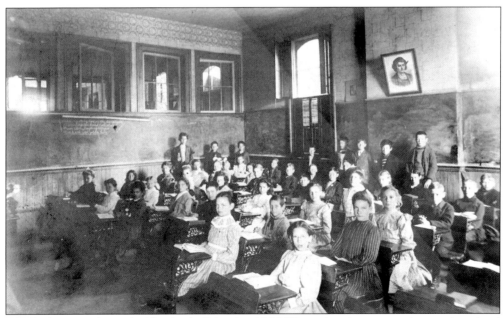

Miss Jackson taught in the Northside School c. 1906. The railroad ran quite close to the school and whenever a train would pass, its whistle would force the teacher to stop talking until the train moved on.

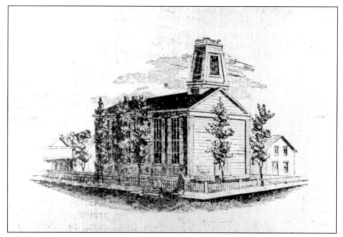 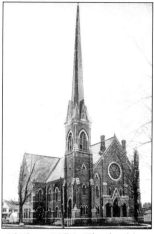

The picture on the left shows the First Baptist church, used from 1842 to 1876. The building was moved to make way for a new brick church, pictured on the right. The church bell was brought in by canal, and it took several days to gather enough men to mount it in the belfry.

Rev. Horace H. Hunt was the pastor of the First Baptist church in Fairport from 1885 to 1897.

The Congregational church was the first church established in Fairport in 1824. Reverend Butler was the pastor of the First Congregational church from 1864 to 1880. He was responsible for the present structure built in 1869 on East Church Street in the village.

Sunday schools were established as early as 1820, and a regular church school was started in 1835. This c. 1890 picture shows Mr. Watters's First Congregational church Sunday school class.

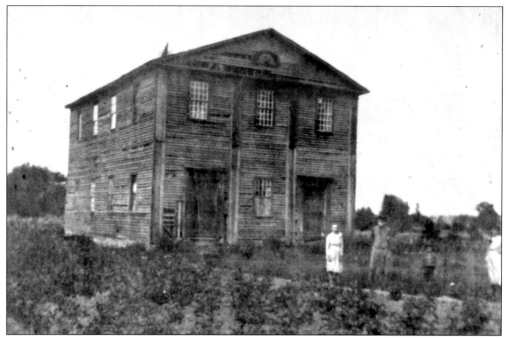

One of the first meetinghouses built in Perinton was the old Methodist church, pictured here in Egypt. Built in 1826, the building was maintained for more than half a century. Note the crops planted right up to the edge of the building. In 1922, the building burned and was never rebuilt.

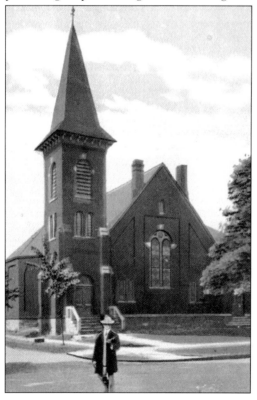

In 1878, the First United Methodist church was built on West Church Street in Fairport. The church was enlarged and remodeled in 1904. In 1955, renovation began in two parts, culminating in 1964 with a new sanctuary and fellowship hall.

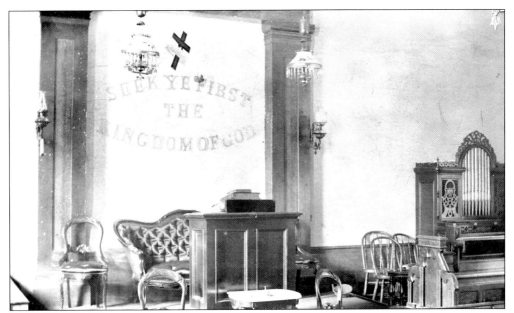

In 1840, 19 members of the Methodist Church of Egypt met and organized the First Free Baptist Church in the village of Fairport. The first building was erected on East Church Street in 1848. Above is the interior of the building before it was moved.

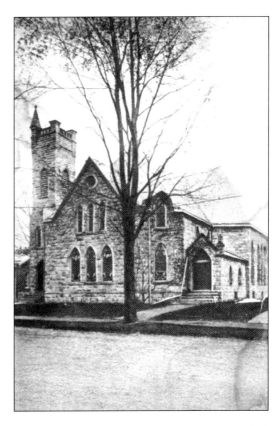

In 1895, the original wooden structure was moved to 154–156 South Main Street and a new stone church was erected in its place. The church, shown here, is known as the Raymond Memorial Baptist Church after Rev. L.W. Raymond, who was responsible for rebuilding the church.

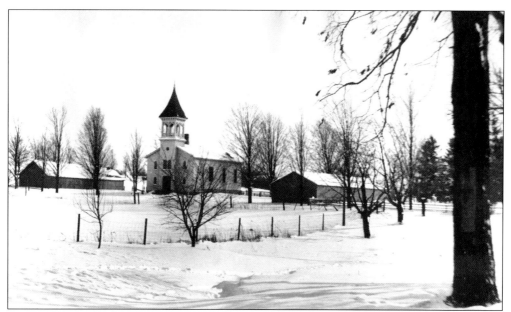

The South Perinton United Methodist Church, dedicated in 1837, is the oldest church building still being used in the town of Perinton. The building, located on Wilkinson Road, is currently a local historic landmark. This photograph is courtesy of the Perinton town historian.

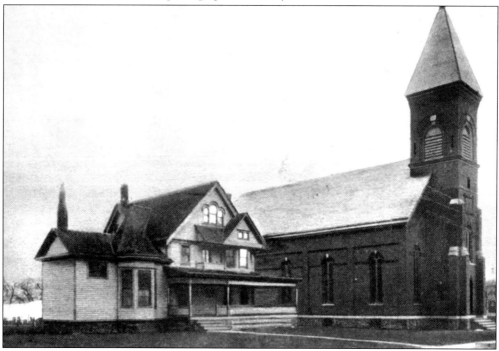

The Erie Canal and the rise of manufacturing brought the need for large numbers of unskilled laborers, especially from Ireland and Italy. Irish Catholics built a Catholic church on the north side of the village on High Street. The first church was built in 1856, followed by this brick church in 1883. The Church of the Assumption, pictured here, was constructed on a lot just across the street from the first church. It faces East Avenue.

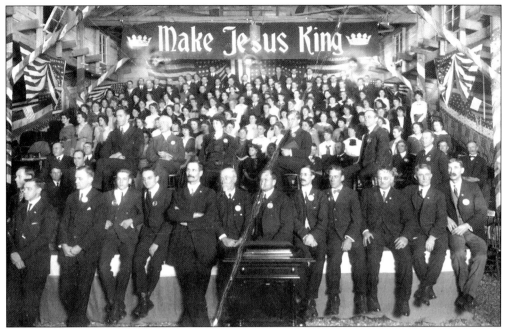

The Great Gospel Tabernacle was built especially for the Burgess and Butts Revival of November 1914. The building was located on the south end of the lot of the former post office on South Main Street and was capable of holding 1,500 people. The message "Make Jesus King" was preached by evangelist George Burgess, seated on stage in the second row, fourth from the left. The director of music, Benjamin Butts, is seated fifth from the left.

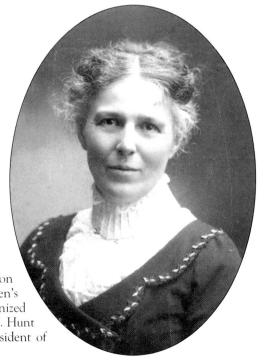

Founded on September 5, 1871, in the session room of the old First Baptist church, the Women's Baptist Missionary Society was the first organized in the Monroe Baptist Association. Mrs. H.H. Hunt was the well-respected and inspirational president of the organization from 1887 to 1899.

The Fairport Historical Club, founded in 1884, was formed for conversation, communication, and intellectual improvement. This picture shows the program committee of 1914–1915. The women are, from left to right, Mrs. George Millner, Helen DeLand, Charlotte Clapp, and Mabel Parce.

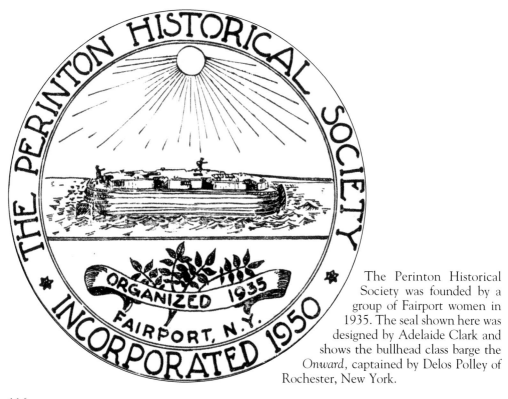

The Perinton Historical Society was founded by a group of Fairport women in 1935. The seal shown here was designed by Adelaide Clark and shows the bullhead class barge the *Onward*, captained by Delos Polley of Rochester, New York.

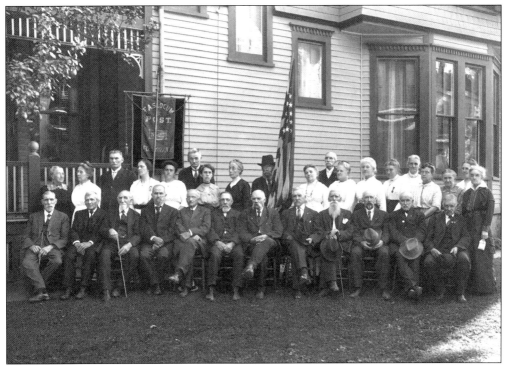

The Grand Army of the Republic Post No. 211 was chartered in Fairport on April 25, 1881. The post was named after 1st Sgt. Edwain A. Slocum of Company A, 8th New York Cavalry. Slocum died on July 1, 1863, at Gettysburg at the age of 27.

The year 1908 marked the beginning of the Fairport Business Men's Club picnic. The men would take a summer Wednesday afternoon off and leave the stores and shops in the care of women clerks. The businessmen of Fairport continued to meet annually for picnics and dinners well into the 1930s.

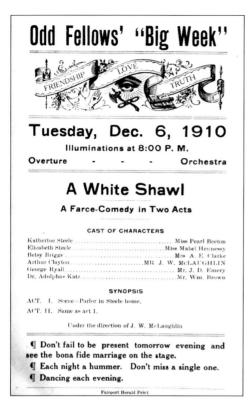
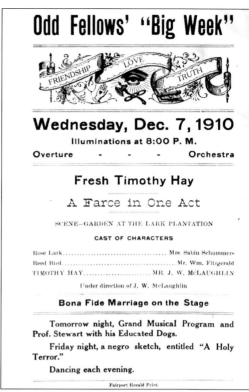

The Odd Fellows organized many skits and plays to benefit local charities. Many of these benefits were in Shaw's Hall. This playbill was for one of many plays put on by John McLaughlin in the early 1900s.

Mrs. Richard Johnson was an early president of the Fairport Woman's Temperance League, founded on April 14, 1877. In 1878, the league changed its name to the Woman's Christian Temperance Union and became an auxiliary of the State Temperance Union. Meetings were held until 1941.

Twelve
Old Home Week

Old Home Week has come and gone, and the word "Success" is written upon every page.
—The Monroe County Mail, August 6, 1908

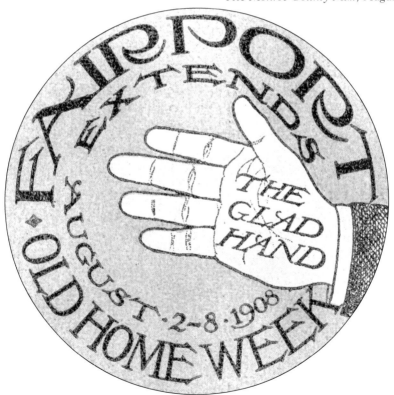

Old Home Week was a signature event in the history of Fairport. It was a celebration of Fairport's success. The community invited the world to this small village of 3,000 people, and visitors came from every state in the union and several foreign countries. Some 3,000 to 10,000 people were there daily and 25,000 on Saturday. This logo was used by the Old Home Week Committee.

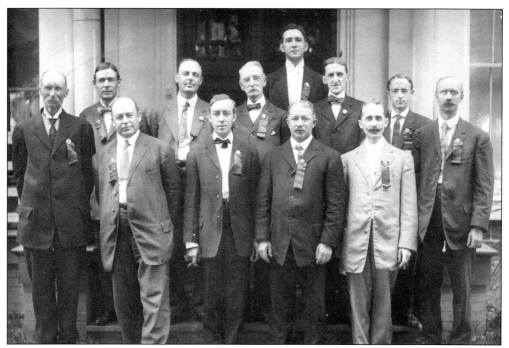

The celebration was planned around the 13th Annual Fireman's Convention, scheduled in Fairport for August 5 and 6, 1908. The members of the Old Home Week Committee are, from left to right, as follows: (front row) P.A. Welch, Edward Ryan, Clarence Green, E.J. Carey, W.O. Green, and Charles McBride; (middle row) A.J. Fellows, George Cobb (chairman), George Taylor (president of Fairport), T. McCarthy, Edward Brown, and Grant Kelsey; (back row) unidentified.

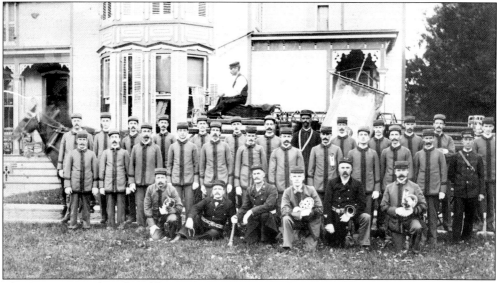

The Fairport Hook and Ladder Company was one of the many local fire departments that participated in the convention. The fire department of Fairport was organized into the following three units: the DeLand Hose Company, Fairport Protective Association, and the Fairport Hook and Ladder Company.

PROGRAM of the WEEK

The Northern-Central New York Volunteer Firemen's Association Thirteenth Annual Convention, Wednesday-Thursday, Aug. 5-6

Seven Days of Pleasant Reunions, Parades, Concerts, Picnics and Many Other Events That Will Be of Especial Interest to All

SUNDAY, AUGUST SECOND—CHURCH REUNIONS

The Churches will hold Special Services, and as many as possible of the former clergymen and members will be present. Union Service in the evening at the First Baptist Church, addressed by Rev. R. E. Burton, D. D., of Syracuse.

MONDAY, AUGUST THIRD—HOME-COMERS' DAY

Grand Salute at Sunrise by the Blowing of Whistles, Ringing of Bells, Aerial Bombs, etc. Registration and Reception of Home-Comers at Town Hall. Sightseeing Automobile Trips. Organ Recital at the Free Baptist Church. Children's Carnival and Pony Show. Band Concerts by the DeLand Military Band. Industrial and Fusileer Parade in the evening.

TUESDAY, AUGUST FOURTH—GOVERNOR'S DAY

Relay Hose Race. Trotting Race. Balloon Ascension and Parachute Leap by the Jewell Bros. of Philadelphia. Pioneer Meeting in Town Hall in the evening, with Reminiscent Addresses. Band Concerts.

WEDNESDAY, AUGUST FIFTH—DELEGATES' DAY

Official Meeting Northern-Central New York Volunteer Firemen's Association at Town Hall. The day will be taken up with Official Business and Entertainment of the Delegates. Athletic Sports and Water Carnival. Band Concerts afternoon and evening. Balloon Ascension and Parachute Leap by the Jewell Bros. Reception and Ball at the Town Hall in the evening.

THURSDAY, AUGUST SIXTH—FIREMEN'S DAY

Morning: Grand Parade and Review of the Northern-Central New York Volunteer Firemen's Association with 1,200 Uniformed Firemen and 25 Bands in line, together with Fire Apparatus. Afternoon: Hose Race. Hook and Ladder Race. Prize Drill. Band Tournament. Balloon Ascension. Evening: Grand Pyrotechnic Display.

FRIDAY, AUGUST SEVENTH—SCHOOL DAY

Reunion of Teachers, Alumni and Pupils. Address by Prof. A. S. Downing, of the State Department of Education, Albany. Band Concerts. Reception and Ball.

SATURDAY, AUGUST EIGHTH—PICNIC DAY

A grand Old Home Basket Picnic will be held at DeLand's Park. Speech Making, Contests, Band Concerts and other events that will fittingly close a week long to be remembered.

EXECUTIVE COMMITTEE

GEORGE W. COBB, Chairman	EDWARD J. CARY, Secretary		
GEORGE A. FELLOWS, Treasurer	GRANT D. KELSEY, Assistant Secretary		
CLARENCE S. GREENE	WILL O. GREENE	EDWARD J. RYAN	THOMAS T. McCARTHY
GEORGE C. TAYLOR	PATRICK A. WELCH	CHARLES W. McBRIDE	

Shown is the program for Old Home Week, which ran from August 2 to August 8, 1908. The logo at the top of the page was designed especially for the event. The slogan for the week was "Fairport Extends the Glad Hand." Thousands of green buttons were handed out with this logo to people who attended the event.

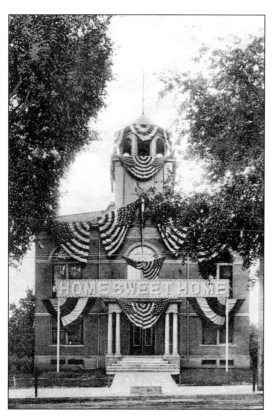

The town hall, shown here decorated for Old Home Week, was the headquarters for the event. On the Monday morning of Old Home Week, people waited in long lines for the hall to open so visitors could register and pick up a program and a button. The *Fairport Herald* was printed every day during the week and could be picked up here for 10¢.

The New York Central Railroad sent two men to be in town for the week. They were to see that the crossing was clear and safe to cross. Trains ran every 20 minutes from Rochester, and there was evening service to Lyons and Syracuse.

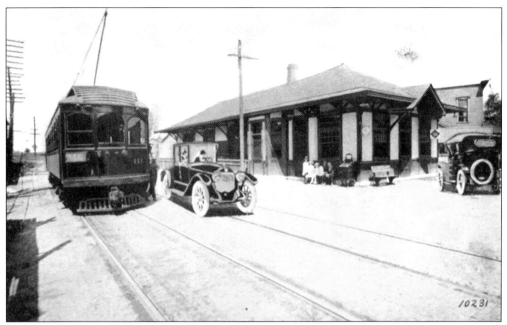

The Rochester, Syracuse, and Eastern trolley sent two uniformed trainmen to help facilitate the handling of the crowds during Old Home Week. Every car for the trolley line was in service, with a car arriving every 15 minutes during the day, each carrying from 90 to 100 passengers.

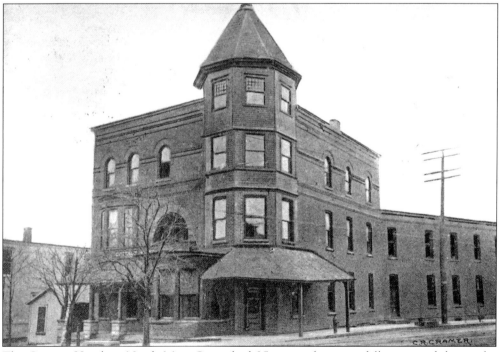

The Cottage Hotel on North Main Street had 35 rooms that were fully occupied during the week. Twelve rooms were reserved just for the visiting firemen.

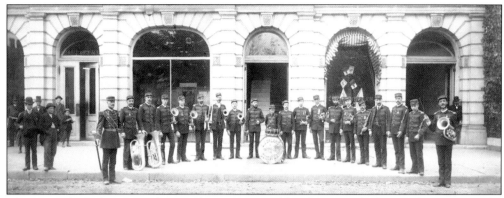

The DeLand Band, organized in 1885, was sponsored by the DeLand Chemical Company. The members pictured here are, from left to right, as follows: L.K. Quakenbush, C. Eggleston, M.W. Wilbur, Robert Wignall Jr., James Wignall, F. Soper, Charles Coon, C.E. Wilcox, W. Bender, W. Butcher, L. Moore, John Wignall, H.R. Wood, J.K. Walsh, W.A. Sproul, T. Byrne, F.T. Jones, Fred Zeitler, H. Sauer, and Robert Wignall Sr. The band was paid $343 for the week.

Robert Wignall, shown here, was the musical director for the DeLand Band. As a longtime member of the band, he coordinated the times and places that each of the 25 bands would play during the week. Robert Wignall's other claim to fame was that he played at the wedding of Queen Victoria's son, future King Edward VII. This photograph is courtesy of Alberta Cleveland.

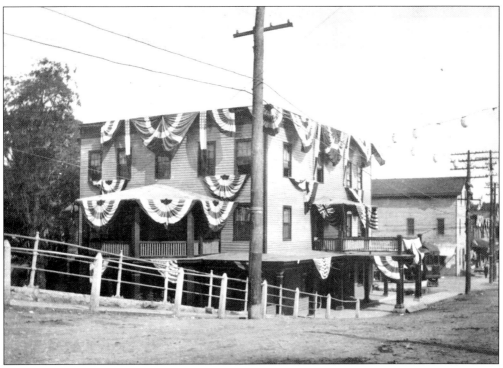
Many of the buildings in the village were gaily decorated with red, white, and blue banners. This photograph, courtesy of Alberta Cleveland, shows the Millstone Block along the canal on North Main Street.

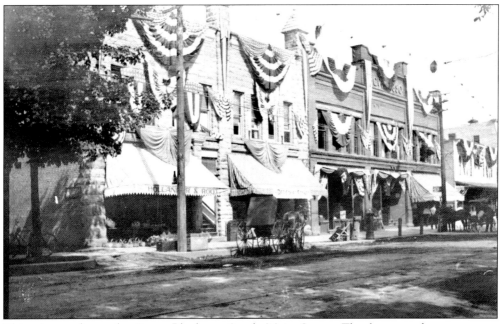
This picture shows the Bown Block on South Main Street. The lanterns that are strung across the street were mounted in a zigzag pattern from Church Street to DeLand Park. This photograph is courtesy of Alberta Cleveland.

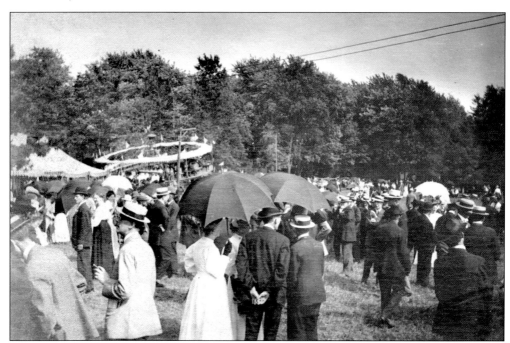

DeLand Park, at the north end of the village, was set aside for entertainment during Old Home Week. There was one large tent and five smaller ones set up to contain the refreshment stands, the amusement rides, and the games. There was dancing every night and a hot-air balloon on the grounds. This photograph is courtesy of Alberta Cleveland.

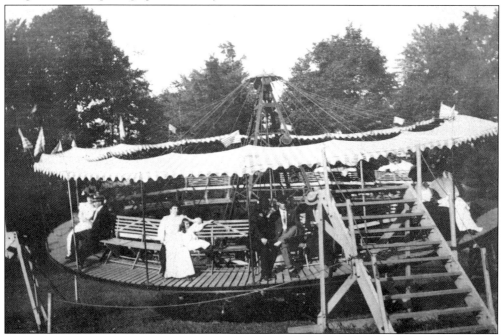

This ride was called the Circling Wave. Other traditional rides, such as the Ferris wheel, were part of the midway. Each night was punctuated by a fireworks display. This photograph is courtesy of Alberta Cleveland.

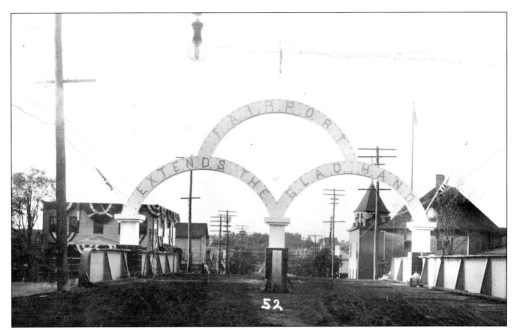

One of the most visible symbols of Old Home Week was the welcoming triple arch. This structure was built across the Main Street Bridge and was illuminated by more than 1,000 four-candle power bulbs. Red lights were used on the border, and white bulbs were used to light up the slogan "Fairport Extends the Glad Hand." The structure was built at a cost of $550.

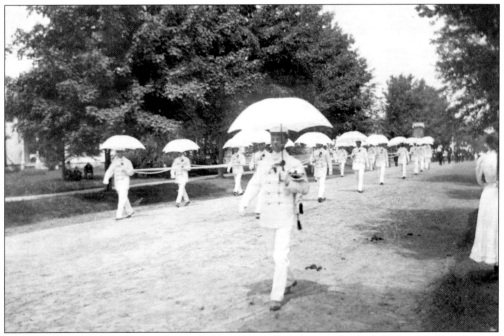

The big Old Home Week parade was held on Thursday, August 6, 1908. Some 1,240 uniformed firemen and 25 bands formed at Potters Place near West Church Street and marched across the canal to DeLand Park in the north end of the village. It took 45 minutes for the parade to pass the reviewing stand.

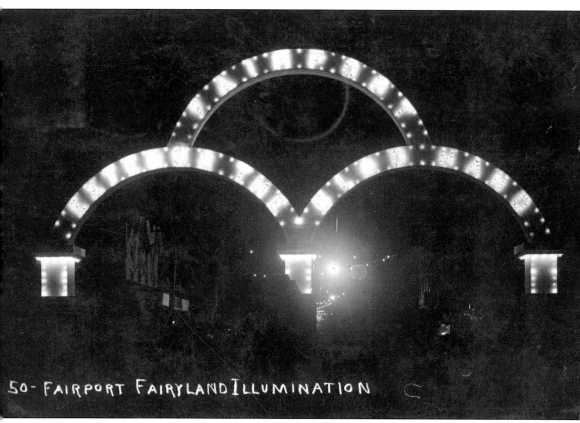

50 - FAIRPORT FAIRYLAND ILLUMINATION

The celebration ended Saturday night, August 8, 1908, but not before the village experienced a shocking series of fires. At five P.M., several incendiary fires were set throughout the village. Fires were set at the rear of the Baptist church, the mail building on West Avenue, the barn across the street, the lumberyard, and several other places in the village. Years later, a fireman who fought the fires that night recalled, "We worked until midnight, but I stayed at the firehall until five in the morning The carnival crowd had brought quite a tough element into town."

The community almost lost the village, and Old Home Week was never again celebrated. It was not until 69 years later that the village of Fairport again invited the entire world to visit. Today, Fairport hosts one of the largest craft fairs east of the Mississippi. The fair annually draws more than 150,000 people on the first weekend in June.